SENSIBLE LIFE

FORDHAM UNIVERSITY PRESS NEW YORK 2016

COMMONALITIES

Timothy C. Campbell, series editor

SENSIBLE LIFE

A Micro-ontology of the Image

EMANUELE COCCIA

Translated by Scott Alan Stuart

Sensible Life was originally published in French as *La vie sensible* by Editions Payot & Rivages in 2010 and in Italian as *La vita sensibile* by Il Mulino, in 2011. © 2010 Emanuele Coccia; © 2010 Editions Payot & Rivages.

Library of Congress Cataloging-in-Publication Data

Names: Coccia, Emanuele, author.
Title: Sensible life : a micro-ontology of the image / Emanuele
 Coccia ; translated by Scott Alan Stuart.
Other titles: Vita sensibile. English
Description: New York, NY : Fordham University Press, 2016. |
 Series: Commonalities | Includes bibliographical references. |
 Description based on print version record and CIP data
 provided by publisher; resource not viewed.
Identifiers: LCCN 2015042996 (print) | LCCN 2015042264 (ebook) |
 ISBN 9780823267439 (ePub) | ISBN 9780823267415 (cloth : alk.
 paper) | ISBN 9780823267422 (pbk. : alk. paper)
Subjects: LCSH: Senses and sensation. | Sensitivity (Personality
 trait) | Image (Philosophy)
Classification: LCC BD214 (print) | LCC BD214 .C6313 2016
 (ebook) | DDC 128/.3—dc23
LC record available at http://lccn.loc.gov/2015042996

Printed in the United States of America

18 17 16 5 4 3 2 1

First edition

CONTENTS

INTRODUCTION

KEVIN ATTELL

> History will record few things lovelier and more moving than this Arab
> physician's devotion to the thoughts of a man separated from him by a
> gulf of fourteen centuries. To the intrinsic difficulties of the enterprise
> we might add that Averroës, who knew neither Syriac nor Greek, was
> working from a translation of a translation.
>
> —JORGE LUIS BORGES, "AVERROËS' SEARCH"

Emanuele Coccia's *Sensible Life* is both a timely and an untimely book. In it
readers will find pages touching on issues at the center of a number of contem-
porary philosophical debates and movements, including, most prominently,
biopolitics, new materialism, posthumanism, object-oriented ontology, theo-
ries of embodiment, and animal philosophy. While all of these terms are, to
varying degrees, capacious and perhaps provisional (indeed, they are often
hotly contested even by the very writers working under these rubrics), they
nevertheless provide a few markers mapping out the contours of the philo-
sophical terrain in which this translation of *La vita sensibile* appears.

It might be something of an irony, then, that one of the central gestures
of this book is to return to and reconsider certain claims and concepts that
have been long dismissed by the modern philosophical tradition—indeed,
as Coccia suggests, claims and concepts whose very dismissal was the
enabling condition for modern philosophy to take its shape and develop.
Such a reconsideration in the context of the contemporary milieu does not
mean "advocating a nostalgic return to the ruins of the past"; rather, it has

the aim of "suspending for just a moment the dogmatic sleep that refuses to allow philosophical citizenship to ideas whose urgency and necessity have been absolutely forgotten." The first among these ideas for Coccia is the medieval notion of "intentional species"—that is, intelligible or sensible forms that are ontologically autonomous from both the raw materiality of the objects that they represent and the subject that perceives them. In the early chapter that takes this term as its title, Coccia identifies in the first moments of philosophical modernity—Descartes, Hobbes, Malebranche—the summary dismissal of what turns out to be perhaps the central claim of the book's argument: that there is a realm of existence that is neither that of the cogitating subject nor that of the material object, but that of the *sensible* (in the original Italian, *sensibile*).

What is the meaning of "sensible"? The term presents some initial problems for the translator and reader, since its connotations in English, though close, do not perfectly align with those in Italian. On the one hand, *sensibile* can be used to describe a person or living organism that has the capacity to sense, though here its meaning is closer to "sensitive" than "sensible," the latter suggesting something like "reasonable" or "of sound judgment." On the other hand, it can also be used to describe an object "that can be felt or perceived" (the OED's first definition of "sensible"), with connotations very close to those in English. Once noted, though, these oscillations of meaning should present the reader no real difficulties.[1] But noting them also indirectly points us toward the book's central argument, and in this sense "*sensibile*" and "sensible" are also fortuitous terms for the translator. This is because they can be applied grammatically to both subject and object, to both the sensing (sensitive) being and the sensed (perceptible) material object (and thus another English word one might hear in "sensible" is the less common "sensate"). In both languages, too, the term can be nominalized ("*il sensibile*," "the sensible") to name, in the absence of a more concrete noun, that which is essentially characterized by the quality of being sensitive or sensible. "Sensible," in Coccia's usage, encompasses all of these meanings, or perhaps better, it names the obscure sphere of existence in which both subject and object must participate in order for there to be perception of a perceptible world.

The paradigm for this concept, again, is the notion of intentional species, a central idea in medieval debates concerning the way we perceive and come to know the material world. Without attempting to do justice to the

evolution of the concept, a few brief glosses might help to illustrate the idea and to lay out the stakes involved in its modern, especially Cartesian, eclipse.[2] A crucial postulate for the species doctrine in medieval thought is one inherited from Aristotle: namely, that what the senses apprehend (that is, what they are sensitive to) is not pure matter itself but sensible forms that are distinct from matter—"just as," in Aristotle's famous example, "the wax receives an imprint of the signet-ring without the iron or gold, and receives the impression of the gold or bronze, but not as gold or bronze" (424a 19–22).[3] Perception, he argues, is based on a receptivity to forms that can be impressed and can remain in a sensible existence separated from their material substrate. These autonomous forms are not the gold or iron itself, and neither is the mental impression merely a product of the sensory apparatus or the mind alone.

Nearly eight hundred years after Aristotle, Augustine in *On the Trinity*, reaffirms the analogy between forms and the wax impression in order to explain how perception indeed entails a receptivity to forms even if (unlike the relatively stable impression in the wax) actual sensory impressions tend to fade from the mind or the senses immediately, continuously giving way to new ones in the flux of perceptual experience. Even though we cannot see the impression in the wax while the ring is still in contact with it, he argues, we do not therefore discount that there is an image impressed in the wax before the ring is separated from it. "But if the ring were dipped into a fluid, no trace of its image would appear after the removal of the ring. Yet our reason should not on that account fail to see that the form of the ring, produced from the ring, was in that fluid before the ring was removed, and is to be distinguished from that form which is in the ring" (*De trinitate* XI, 2).[4] As fleeting and ephemeral as can be, the image a ring might impress upon, say, water is no less an image for its fragility. The analogy still holds.

And Aquinas, writing about eight hundred years after Augustine and drawing now on a thick tradition of medieval Christian and Arabic-Latin thought, describes a hierarchy of knowledge, culminating in God's total knowledge, on the basis of the separability of species from matter, arguing that "a thing's freedom from matter is the reason why it is able to know; and the capacity to know is in proportion to the degree of freedom from matter. . . . The senses are able to know because they are able to receive the likenesses of things without the matter [*quia receptivus est specierum sine materia*]; and intellect is still more capable of knowing because it is freer

from matter and unmixed, as we read in Aristotle" (*Summa theologiae*, Ia. q.14 a.1).[5]

These examples from Aristotle, Augustine, and Aquinas provide brief illustrations of the notion of *species*, or *form*, and they show, albeit roughly, how for ancient and medieval thought the detachability of form from matter was a basic postulate in debates about the nature of sense and knowledge. While one gets a sense of the vast archive of primary and secondary material concerning the perception of forms in the pages (and in the margins of the pages) that follow, the figure of medieval Aristotelian philosophy that is perhaps most crucial to Coccia is Averroes, the subject, in fact, of his 2005 book, *La trasparenza delle immagini: Averroè e l'averroismo* (The Transparency of Images: Averroes and Averroism). Among the many things that the scholasticism of the later medieval period inherits from Arabic philosophy is a renovated sense of the other word in our key term: *intentio*. As Leen Spruit notes, the scholastic *intentio* is the Latin translation of the nearly synonymous Arabic words *ma'qul* and *ma'na*, whose general meaning (allowing for variations in usage among the Arabic writers) is "a concept or thought *in its relation to* things that exist outside the soul."[6] That is, *intentio* is the relation—or medial relationality—itself. Coccia reaffirms the point that the late medieval Arabic-Latin *intentio* is to be distinguished from the modern notion of intention or intentionality, insofar as the modern usage (perhaps more like the Augustinian usage) is at base a feature of subjectivity, writing that "one understands nothing of the medieval theory of intentionality if one turns it into the object of a conscious subject: *intentio* is related not to a subject, but to a medium."[7] This is why "a theory of knowledge is above all a theory of species, or intentions, and thus founds an intentional, or . . . *special* ontology. Intentional being is the being whose essence is that of a species, a pure knowability: *intentio*. An intention is nothing but the existence of a form insofar as it is knowability: it is the way in which forms exist in the medium."[8]

In extremely reduced form, this is the field of thought to which Descartes, in a phrase that Coccia cites and elaborates upon, is referring when he speaks in the *Optics* of modern thinkers now being "delivered from all those small images flitting through the air, called 'intentional species,' which worry the imagination of Philosophers so much."[9] It is, then, more than a mere rhetorical convenience that the originator of modern philosophy so summarily and dismissively rejects the concept of intentional spe-

cies, and in doing so marks the decisive opening of rationalist epistemology and the enduring foreclosure of an avenue of thought that Coccia here seeks to retrace and reopen.

Descartes begins the *Optics* with a phrase that sounds as if it could come from the pages of this book: "All the management of our lives depends on the senses," and from there, since "sight is the most comprehensive and noblest of these," he goes on to inquire rigorously into the nature and process of vision, focusing sharply, so to speak, on such things as the function of light rays, the mechanics of refraction, the design of optical lenses, and the physiology of the sensory apparatus.[10] In truth, the *Optics* is presented as a sort of technical manual for lens makers (especially telescope makers), and Descartes's examination of the physiology of vision in the treatise is framed largely as a preparatory lesson for those who will be grinding the glass. It is, however, also the case that a frequent refrain in the treatise is the polemic against the scholastic theory of intentional forms, and against the idea that there is any autonomous substance or existence to images as such. Indeed, while this critique may appear only obliquely in the text, one of the underlying tenets of Descartes's account of vision is that there is no transmission of anything like an "image" at all in the act of seeing. It is worth briefly recounting here the logic of Descartes's argument, since it neatly demonstrates the conjunction between his work on the science of perception and the rigorously dualist structure of his nascent rationalist epistemology.

What happens when we see (and more broadly, sense) an object? To be sure, when we see something, we have a sort of image of it in our minds, but for Descartes—and he is not without precedent in this—the perception is created or composed internally by the soul out of the raw and formless data arriving in the brain from the sensory nerves. "We already know sufficiently well," he writes, "that it is the mind which senses, not the body."[11] In a certain sense, the eyes do not perceive anything at all, since there is no *image* there to "see," only the light rays that bounce off external material objects and are then focused through the lens of the eye onto the screen of sensory nerves at the eye's back wall, which in turn transmit the data up the optical nerve to the brain, where perception proper occurs. Where is the image? It is in the brain, a psychic reality.

How might one best illustrate this process? Oddly enough, Descartes immediately chooses the example of the blind person who uses a cane to

form a perceptual image of the world. While a sighted person, he argues, may have on occasion had the experience of having to use a stick to grope clumsily along a rough road at night, those who have been born blind and have used a cane from early life appear to be so good at it that "one might almost say that they see with their hands, or that their stick is the organ of some sixth sense given to them in place of sight."[12] The crux of Descartes's example, which comes in the third paragraph of the treatise, is that the perceptual relation between the eye and the light ray (and any sensory organ and external stimulus) functions more or less according to the same mechanism as that between the blind person's hand and the cane by which he or she touches the rough road. Descartes's comparison of seeing objects to perceiving them through the cane that touches them and in turn causes movement in the hand—that is, a perception that is at base a physical contact and touching through a prosthesis—is not merely a rough analogy, nor is it one he mentions just once in passing. Indeed, on closer inspection one finds that the blind person's cane is the true paradigm for Descartes's account vision and of sensation in general. Indeed, the cane is precisely described as the "organ of some sixth sense," and this sixth sense works just as the sense of vision does; in fact—and this is the import of the analogy—vision works according to a process that is *much more clearly illustrated* with the example of the blind person's cane. The analogy, or better, identification, between seeing and touching is so pertinent for Descartes because, in contrast with what we might be easily misled into thinking about vision, it is so much more difficult to postulate an interceding "image" passing from object to hand along the length of the stick. As he writes: "When the blind man of whom we have spoken above touches some object with his cane, it is certain that these objects do not transmit anything to him except that, by making his cane move in different ways according to their different inherent qualities, they [as do light rays through the eye] move the nerves in his hand, and then the places in his brain where these nerves originate."[13]

Whatever merits Descartes's argument might have—and, of course, it does have many—it is nevertheless worth noting that his insistence on this analogy and on the fact that vision is nothing but the physical movement of nerves caused by light rays is animated by his polemic with the scholastic species doctrine, the idea of a projection into "the sensible" of an image

that in some way resembles or represents the object: "It is necessary to beware of assuming that in order to sense, the mind needs to perceive certain images transmitted by the objects to the brain, as our philosophers commonly suppose; or, at least, the nature of these images must be conceived quite otherwise than as they do"[14] There is little doubt that Descartes's injunction not to assume what the scholastics took for granted about the ontological autonomy of the image marked the opening of the path that soon became the main throughway of rationalist philosophy. But what avenues were passed by?

From the perspective of Coccia's project, perhaps the most crucial aspect of the species doctrine, and of the intricate debates concerning it, is the assumption that the species or form does not reside wholly in the mind of the thinking, perceiving subject (except perhaps God) and that there is a sensible image or a likeness that exists as a nexus point between perceiving (mental or spiritual) subject and perceived (material) object. Such a structure, which entails a distinct though elusive third space, the medial space of the image, derails or is historically derailed by rationalist epistemology and its rigorous dualism. In Coccia's words, "the existence of the sensible, insomuch as it is at the same time separate from the subject as well as the object, in effect renders impossible any reduction of the theory of knowledge to psychology or to a theory of the subject."

The species doctrine and the Arabic-scholastic notion of *intentio*—and just as important, the modern, specifically Cartesian, rejection of them—are key elements not just in the opening gambit of the pages that follow, but also in the fine weave of the book's entire fabric, and indeed in many of its most striking *images*: dreams, seeds, clothes, skin. With the retraction of both the Cartesian dismissal of intentional species and the rigorous dualism of perceiving subject and perceived object, the phenomenon of the image—which is to say, the phenomenon as such, which *is* the image—can be described and conceived in fundamentally new terms. Even if viewed as a sort of methodological bracketing, a momentary suspension of that dogmatic sleep, this reframing of the subject, act, and object of perception allows for strikingly new perspectives not only on enduring philosophical questions but also on everyday objects and experiences. Take, for example, the image we see every day in the mirror. As Coccia writes in his book on Averroes,

In the mirror a thing or a form exists in a particular way: it is no longer that which it is, but rather the species or the *intentio* of that which it is. In other words, it does not exist but as species, as knowability and image. The enigma that the experience of the mirror allows us to formulate is this: how do forms exist when they become actualized knowability? And what are the essential attributes that define the peculiar form of existence of knowability?[15]

In Chapters 6–8 of *Sensible Life*, Coccia takes these questions up again and offers an account of the image of myself, my body, in the mirror not as a mere reflection of light rays that the eye senses and the mind perceives (and neither as a Lacanian objectification of the self) but instead as an autonomous image existing in a region of being beyond (or between) those of psychological subject and objective material extension. Indeed, that image in the mirror short-circuits this rigorously dualist opposition, since it exists (albeit fleetingly and precariously) in a space other than those of mind and matter. The image itself certainly does not think; neither does it have any material consistency. "In the mirror," he writes, "or better within the mirror, our form, *our selves*, momentarily transform into something that *does not know* and *does not live* but remains perfectly sensible, or better *is* the sensible par excellence." What makes the image reflected in the mirror so *special*, in the etymological sense of the word, is not that it shows my body to be an object but rather that it shows it (and everything else) to exist as a species, a form, an image displaced from its "proper" material or mental space into a separate ontological sphere. This other space between or beyond the *I think* and the *I am* is the "place of images" that Coccia's "micro-ontology" sets out to map and describe.

In Jorge Luis Borges's story "Averroës' Search," Aristotle's great commentator is confounded by two words in the *Poetics*, "tragedy" and "comedy," for which he can find no equivalent terms or concepts. Yet the entire treatise of the *Poetics* seems to revolve around them. Later in the story, Averroes spends an evening in company hearing tales of wonder told by a man recently returned from China, where he witnessed the strangest events. One day in Canton, for example, he visited

a house of painted wood in which many persons lived. It is not possible to describe that house, which was more like a single room, with rows of cabinet-like contrivances, or balconies, one atop another. In these

niches there were people eating and drinking; there were people sitting on the floor as well, and also on a raised terrace. The people on this terrace were playing the tambour and the lute—all, that is, save some fifteen or twenty who wore crimson masks and prayed and sang and conversed among themselves. These masked ones suffered imprisonment, but no one could see the jail; they rode upon horses, but the horse was not seen; they waged battle, but the swords were of bamboo; they died, and then they walked again.[16]

Strange behavior indeed, though not, as one of his listeners suggests, the acts of madmen; rather, the traveler explains, this was the presentation of a story. Yet even this explanation does little to reassure the group of friends that this performance is not an utter absurdity, for after all, rather than have twenty people act out a story, a single speaker could simply tell it directly to his listeners. What need could there be, when a single person can recount any tale, any experience, for this wild pantomime on the raised terrace?

In *Sensible Life*, Coccia similarly invites us to such a spectacle, where something beyond the subjective and the objective, the psychological and material, unfolds. Unlike the Cartesian account of the inert medium (the air, the cane) that is merely a conduit or a prosthesis through which movements and forces are conducted untranslated and unaltered from solid matter to sensory nerve, Coccia gives us the notion of an autonomous "medial space" in which images as such come into being, that is, "a secret natural theater where everything comes back to manifesting itself; it is a stage that is in constant movement, opening the world to another life, a life that is different from the life that everything has in matter and in minds." Coccia's "micro-ontology of the image" attempts to enable us to see the drama that is always unfolding in this theater, and perhaps to feel what life is like on that stage.

Il faut de la vie pour soutenir la vie.
—JULIEN-JOSEPH VIREY

1

SENSIBLE LIFE

It happens even when our eyes are closed or when all our senses seem to be shut to the outside world. If it is not the sound of our own breathing, then it is a memory or dream, tearing us away from our seeming isolation and submerging us once again in the sea of the sensible.[1]

We like to imagine ourselves as rational beings who think and speak, yet to live means first and foremost to look, taste, feel, and smell the world around us. We can live and know how to live only thro ugh the senses, and not simply to have knowledge of what surrounds us: Sensation [*sensibilità*] is more than a cognitive faculty. Our very own body is, in all respects, sensible. We are sensible to the same extent and intensity with which we *live* from and within the sensible: We are for ourselves and can only be for others a sensible appearance. Our skin and our eyes have color, our mouth has a certain taste, and our body continuously emits lights, odors and sounds as it moves, speaks, eats, and sleeps.

We live from the sensible, but this is not a question of simple physiological necessity. In all that we are and all that we do, we have dealings with the sensible. Our daily bread is not a sum of principles that nourish us but an infinite spectrum of tastes, a reality that exists solely in a precise palette of colors and temperatures. Only through the mediating gleam of our sensible imagination we do have access to our past and our future. Moreover, we relate to ourselves not as we relate to an incorporeal, invisible essence but as to something with sensible consistency. We spend hours every day altering the natural fragrances, shapes, and colors of our body as well as of the world that surrounds us. We want exactly that fabric, that cut, that color and pattern. We go to great lengths to ensure that certain, specific smells

predominate within the spaces we inhabit. We trace signs on our skin, our faces and our bodies. We color around our eyes and paint our nails—as if we were dealing with brands, effective talismans upon which our futures depended.

This is no narcissistic obsession: Caring for the world in which we live means caring for its sensible structure. We relate to the world not through an act of immaterial contemplation, nor through a pure practice. Our relationship with the world is a sensible life: an uninterrupted production of sensible realities made of sensations, odors and images. All that we create and all that we produce is made of sensible matters—beyond our own words, it is the tissue of the things in which we realize our will, our intelligence, our most violent desires and most disparate imaginations. The world is not simply extension; neither is it a collection of objects, and it cannot be reduced to an abstract possibility of existence. To *be in the world* means, before anything else, to be within the sensible, to move within it, to make and unmake it without interruption.

Sensible life is not only what the senses stir within us. But it is also the manner in which we give ourselves to the world, the form that allows us to be *in* the world (for ourselves and for others), and the way in which the world becomes understandable, accessible, and livable. Only in sensible life is a world given to us, and only as sensible life are we in the world.

2

MAN AND ANIMAL

According to tradition, sensible life is not exclusively a human trait. On the contrary, sensation has always been considered to be the faculty through which "living things, in addition to possessing life, become animals."[1] Through the senses, we live in manner *indifferent* to our specific difference as humans, as *rational animals*: Sensation gives form and reality to that which, in our life, is not *specifically* human.

According to the same tradition, sensible life is that particular faculty which allows certain living beings—animal life in all its forms—to relate to images, where for images we understand broadly all forms of the sensible world, whether they be visual, smelling, or auditory. Sensible life is the life that images themselves have sculpted and made possible. Every animal is a particular form of opening to the sensible, which is to say a certain capacity to appropriate and interact with images. "Just as the vegetative faculty requires food to be active, so the sensible faculty likewise requires the sensible," writes Alexander of Aphrodisias.[2] If the sense faculty is that which gives a name and a form to all animals, then images play a role not dissimilar to food in defining the way in which each one lives. Life requires the sensible and images in the same way it requires nourishment. The sensible thus defines the forms, the realities, and the limits of animal life. In order for life to exist, in order for it to be given as experience and as a dream, "it is necessary that the sensible exists."[3]

Inquiring after the nature and the forms of existence of the sensible allows one to fathom the conditions of possibility of life in all its forms, human and animal. The distance that separates human life from the rest of animal life is, in fact, not an unbridgeable abyss that separates sensibility

from the intellect or the image from the concept. A large part of the phenomena that we call spiritual (whether we mean dreams or fashion, speech or art) not only *presupposes* some form of commerce with the sensible, but is made possible *only* by the capacity to produce images and to be affected by images. Between man and animal there is only a difference of degree, not of nature: That which makes man human is only the intensity of the sensation and of the experience, the strength and the effectiveness of images on our life. The sensible in which we live and are worldly beings is not assigned to us like an irrevocable destiny. We do not have one single coat, one single voice, one single expression; the lights, sounds, and odors through which we are given to the world can change at any instant. The relation to the sensible, which we ourselves are, the relation to the phantasm that we embody is always *poetic*, it always requires the mediation of a doing, of individual and collective techniques.

Barely fifty years ago, Helmuth Plessner could still believe that the enigma of "what specific possibilities man derives from his senses, those to which he may trust and depends on" as one waiting for a solution. His project of an "esthesiology of the mind"—which was then more precisely defined in the a context of an "*anthropology* of the senses"—should in fact be inverted; rather than ask for the specific possibilities that man derives from his senses, we need to know what form sensible life can have, for man as for animals.[4] In man and in his body, what is the sensible capable of? How far do the power, activity, and influence of sensation go in human activity? Moreover, what is the stage of sensible life, what is the modality of this life of images, which we are accustomed to calling "man"? This dialectical inversion does not consist in simply a change of our point of view. Rather, it is a matter of not presupposing a human nature beyond the powers that define it.

In order to understand "what specific possibilities man derives from his senses, which he may trust and depend on" we must resolve a double enigma. First, it will be necessary to examine the mode of existence of what we call *sensible*. Such is the task assigned to the first part of this book. But if sensible life does not necessarily have human origins (without yet being foreign to man), the science of the sensible—and by an easy syllogism the science of the living—has a vaster and more general scope than a simple anthropology. The science of the sensible may be articulated only in terms of a *physics* of the sensible.

On the contrary, an anthropology of the sensible is not concerned with the way in which images exist in front of a human subject, who is endowed with senses. Instead, it must study the manner in which the image and the sensible *give body* to activities of the spirit and give life to man's own *body*. It is to this requirement that the second part of the book attempts a response.

3

INTENTIONAL SPECIES

With the onset of modernity, a strange fate weighs on sensible life. Political power and theology were not the only ones to have taken up arms against it—just as they had in late antiquity against icons. Philosophy, too, has made of it a true pariah: It has decreed that the sensible has no existence separate or separable from the subject who knows the real through the mediation of the sensible. Sensible life is rigorously limited and reduced to an *internal* accident of psychism. It exists solely *within* the subject and never outside of it. Sensible life represents an inferior stage, which is private and incommunicable, of the authentic cognitive act that is consummated in the higher chambers of the understanding and the mind.

The refusal to acknowledge that the sensible has any ontological autonomy is more than one of the many founding myths that modernity has devised and cultivated: In the seemingly insignificant gesture with which René Descartes attempted to liberate the mind from "all those small images flitting through the air, which are called '*intentional species*,' and which worry the imagination of the philosophers so much," what was in fact played out was philosophy's decisive battle against its own past.[1] The crusade against an opinion that Hobbes would define as "worse than any paradox, as being a plain impossibility," rallied almost every thinker that positioned himself under the flag of modernity.[2] Unsurprisingly, each of them had to set out their own theory of truth, affirming that "it is unlikely that objects transmit images, or species, that resemble them," as Malebranche puts it in *The Search After Truth*.[3]

The reasons for this unanimity are easy to understand. Only through the definition of what may seem to be a simple gnoseological detail does it

become possible to think a subject *truly* autonomous from the world and from the surrounding objects. Only the exile of intentional species has made it possible for the subject to coincide with thought, as activity and as result, in all of its forms. With Descartes, sensation and sensitive life (exactly like thought and intellectual life) can be explained only if we take the subject as a point of departure; there is "no need to assume that something material passes from the objects to our eyes to make us see colors and light," but neither there is need for "anything in these objects to be similar to the ideas or the sensations that we have of them."[4] The existence of man is sufficient in itself to explain the existence of sensation and its functioning:

> just as nothing comes out from the bodies that a blind man senses which must be transmitted along the length of his stick into his hand, and as the resistance or the movement of these bodies, which is the sole cause of the sensations he has of them, is nothing like the ideas he forms of them.[5]

In the eyes of the moderns, the intentional species seemed like a useless obstacle preventing one from thinking subjective perception *iuxta propria principia*: The existence of the sensible, separated at once from subject and from object, makes it effectively impossible to reduce the theory of knowledge to psychology or to a theory of the subject. Every theory of the images thus becomes an accidental branch of anthropology. And conversely, it is only by removing these "images" from every spiritual act that one has been able to consider the self-reflection of the subject as the formal and the material foundation of all knowledge.

The truth and the coherence of the Cartesian trilemma are threatened by the existence of intentional species. An intention is a shard of objectuality that has pierced the subject, hindering it from transiting from the *cogito* to the *sum res cogitans* without an ontological leap. Vice versa, such an intention depicts the subject as projected toward the object and toward external reality of a nonpsychic character (literally *tending* toward it). If it is thanks to these *species* that we are able to feel and think, then each sensation and every act of thought will demonstrate not the truth of the subject or its nature, but nothing other than the existence of a space within which the subject and the object are confounded.

As absurd as it may appear to those who for centuries have been accustomed to considering it as nothing more than a primitive phantasmagoria

of the way in which we come to know things, the doctrine of intentional species was inspired by "phenomenological" evidence. To reexamine today the reasons and the evidence behind a theory has "so worried the imagination of the philosophers" does not mean advocating a nostalgic return to a past buried among ruins. Rather, it is a matter of interrupting for just a moment the dogmatic slumber that refuses philosophical citizenship to ideas whose urgency and necessity we ourselves can no longer recognize. It means placing ourselves, for once, before images and before their existence with eyes a bit freer from prejudice, a bit more perspicacious than those of Descartes's blind man.

Physics of the Sensible

4

THE WORLD OF THE SENSIBLE

Images—what the sensible life is made of—do not have a pure mental or psychic nature. If it were so, we could simply close our eyes to see, feel, and taste the world. We would not need sounds to hear, nor would we need to hurl ourselves to the skin of the objects to feel the surface of the world or have to place food upon our tongue to taste its flavor. The color of things is not the light that lies in the depths of our eye, nor is it the glow that we perceive as we fall asleep that illuminates the world. That light is different as it comes from outside of us.

The existence of the images does not even coincide with the bare existence of the world and its objects. Philosophers have ceaselessly debated how to deduce the existence of the real beginning from sensations exactly because things are not perceivable per se, through their material existence. Things need to *become* perceivable: not because they are hidden or unknowable but because they become perceivable only through a certain process (and not simply thanks to the fact of their existence). They become perceivable only outside of themselves, but this becoming occurs before they enter into the human sensory system.

The sensible, therefore, does not coincide with the *real* because the world in itself is not sensible; it needs to *become sensible* outside of itself. A simple experiment, already laid out by Aristotle in *De anima,* is sufficient to demonstrate it as such: "If a coloured object is placed in immediate contact with the eye, it cannot be seen."[1] The interaction of an object with a subject is not enough to produce perception. If an object were *essentially* visible, and visible *in itself,* simply bringing it as close as possible to the subject would render its vision more intense. Instead, the very opposite occurs: If the object

acts directly upon the eye, then it can no longer be seen. One could argue that this principle is valid solely for sight due to the existence of light, but that is not so. As Aristotle explains, "the same occurs also with sounds and smells; if the object of either of these senses is in immediate contact with the organ no sensation is produced."[2] The real object, the world, the Thing has to *become* phenomenon, and the phenomenon—outside of the thing itself—has to meet our organs of perception.

In more technical terms, we might say that things (the fragments of the world insofar as truly existent objects) are *genetically* distinct from things as *phenomena* and as *images*, that is from the world as sensible, as something able to be experienced. The process that things need in order to *become* sensible is therefore different in time and in being from the process that allows them to exist. Such a process is also separate and distinct in time and in being from the movement through which things are perceived by a knowing subject. Therefore the genesis of the image, the becoming sensible of the things, coincides neither with the genesis of the thing itself nor with the genesis of the sensation or that of the psychic contents of a mind. The sensible, that is the being of images, is *genetically* different from the known objects as well as from knowing subjects. In the words of Aristotle, we would say that it has a different nature from the soul as well as from the bodies.[3] Nature (*physis*) is nothing but the way in which things are born and the force that makes their birth possible. Or, as Giambattista Vico puts it, the nature of things is nothing but their birth.[4] Aristotle called physics— or natural science—the science that studies the mode of generation of things and deduces their essence from this very mode. The birth or genesis of any particular thing is the extreme form of movement or becoming of which it is capable: It is the place where the movement is not just a simple, external accident but rather touches and gives form to being, is immediately responsible for what an object is. Moreover, it is also responsible for the very *fact* that it is. Something has a *nature* only because and insofar as its Being is an effect of the movement it is capable of and within which it exists, generates itself, destroys itself and does all that it is capable of. Physics is thus a sort of transcendental genetics: a knowledge that lets the essence of something coincide with the way in which it is born: the identity of each object perfectly corresponds with the force that permitted it to constitute itself. In other words, *tell me how you were born, and I will tell you who you are.*

Therefore the physics of the sensible—the *natural* science of images—cannot correspond with psychology (because physics predates and founds psychology), but neither can it be reduced to a science of things, to physics in the strictest sense of the word. The image, in fact, does not perfectly correspond with the thing in its bare existence, for the same reason that the world itself is not an evident and sensible entity in itself. Between *reality* and *phenomenon* there is a gap that cannot be abolished, and it is only by observing *how* images generate themselves that one can define what they are. In order to grasp the genesis of images, one must not wait until they have already engendered. Instead, one must understand *where* this birth shall take place and thus lie in wait, spying on their delivery away from the things, and understand what makes their birth into this world possible.

5

INTERMEDIARIES

Phenomena live on this side, literally, of the soul, but they are beyond things. That is, the place in which things become phenomena is not the soul, but neither is it material existence. Aristotle writes that for there to be something sensible (and therefore for there to be sensation), "it is indispensable that there be *something* in between " [*hōst'anagkaion ti einai metaxy*].[1] There is always an *intermediary* place between us and objects, a womb in which the object becomes sensible, a space in which it becomes *phainomenon*. It is in this intermediary space that things become capable of being sensed, and it is from this intermediary space that living beings harvest the sensible with which they nourish their souls day and night. To observe and hear oneself, all animals have to build their own image outside of themselves, in a space exterior to them: Only within a mirror do we become sensible, and it is in that mirror that we look for and find our image, and not simply in the breathing of our own bodies. It is only after having uttered some words that we are truly able to *hear* what we have said. Restating the impossibility of an immediate self-perception is not sufficient: we must acknowledge that we always become *perceptible*, even to ourselves, in a space which is somehow exterior, intermediate between the ego [*io*] that perceives and the ego that is perceived. It is only *outside oneself* that something becomes capable

> Democritus was mistaken when he said that if the medium and the void were the same, one would be able to see an ant clearly with the sky. This is impossible.

of being experienced: something becomes sensible only in the intermediate body that lies between the subject and the object. It is this *metaxy* (and not directly the things in themselves) that provides us with all of our experiences. It is this very *medium* that relentlessly exudes light and color, sounds and odors. The experience, the perception, is not made possible by the immediacy of reality, but rather by the relation of contiguity (*synechous ontos*) that all animals have with the intermediary place or space where reality becomes sensible and perceivable (*per suam continuationem cum vidente*). To be sure, such a space is not void. It is itself a *body*, but ever changing, in relation to the different forms of sensate entities: It has no specific name but does have a common capacity, namely that of being able to generate images. In the womb of this medium, corporeal objects become images and can act immediately upon our organs of perception. Perception exists only because there is *metaxy*. Sensate experience takes place only because beyond things and minds there is something with an intermediary nature.

> *Actio visus non perficitur nisi per diaffonum medians.*

6

MIRRORS

A medium is an intermediary body that is simultaneously exterior to both subjects and objects. It allows objects to transform their way of being and thus to become "phenomena," while it permits the subjects to find the images and sensate forms they needs to live. Mirrors are the best example of incarnation of these intermediary bodies: They represent the original paradigm of what modernity called *media*. If for centuries the mirror has represented and embodied the metaphor for every theory of knowledge, it is because in the mirror the subject experiences something much more intriguing and uncanny than the alienation or the reification of the self.

Each time we look at ourselves in a mirror, we do not merely experience the narcissistic doubling of our conscience between an "I" subject and an "I" object. In the mirror, or better within the mirror, our form, *our selves*, momentarily transform into something that *does not know* and *does not live* but remains perfectly sensible, or better *is* the sensible par excellence. Every time we gaze upon ourselves in the mirror we become, within it, a purely imaginal [*immaginale*] reality, whose only feature is to be *sensible*, which is to say *a pure image without conscience and without body*.

Far from rediscovering the flesh of perception, in the mirror we enjoy a condition where we are sensate but without having flesh or thoughts, pure percepts, without organs and without conscience. In this state we simultaneously cease to be thinking subjects and material objects that occupy space. We suddenly lose our body—which lies on our side of the mirror—but we also withdraw from our soul and from our conscience, which is also incapable of existing *through the looking glass*.

The experience of the mirror, therefore, is the experience of doubling. This doubling simultaneously establishes two distinct spheres, which follow a completely original logic. On the one hand, we have the sphere of subject-I *and* object-I, of flesh *and* mind, and matter *and* intelligence, which coincide exactly and which coexist without difficulty. On the other hand, there lies the sphere of images, which exists separately as if in exile from the world in which the body and soul coexist, as if images were disjoined from the subject *and* the object at the same instant and with the same intensity. On the one side there is the subject that sees and is seen, which is body and soul; on the other side we exist merely as the result of the act of vision, as a pure being of sensate images. Thus, in the mirror, the image makes itself known as what stands opposite to bodies and subjects, to matter and soul; as that which is simultaneously external to the bodies of which it is the image and as external to the subjects to whom it gives the possibility of thinking these very bodies.

The mirror demonstrates that the visibility of a thing is *truly* separate from the thing itself, just as it is separate from the knowing subject. We are in front of our own image, in front of our purely sensate reality; our image, however, the image that make us knowable, exists *in another place* than where we reside as knowing subjects and known objects. The *cogito* that can be formulated in front of the mirror is, ultimately, the following: *I am no longer where I exist nor am I where I think*. Or: I am sensate only where *one* no longer lives and where *one* no longer thinks.

7

THE PLACE OF THE IMAGES

In the mirror, we suddenly become *pure image*; we find ourselves transformed into the pure, immaterial, and extensionless Being of the sensible. Our form, however, an appearance that was purified from everything that is not perceptible, now exists *outside* of us, *outside* of our body, and *outside* of our consciousness. We have become the pure Being of appearance, but only in front of ourselves. On this side of the mirror, in the world in which we are soul and matter, appearance is impurely mixed with other elements.

Perhaps this is the grand secret that mirrors have safeguarded for ages: They teach that every image—a sensate form as such—is the existence of a form *outside of its proper place. Any form and any thing that ends up existing outside of its own place becomes an image.* Our form, for example, becomes image when it is able to live beyond and outside of us, beyond our soul and beyond our body, without becoming a body itself, remaining on the surfaces of other objects. An image is like the ruse employed by forms to escape the dialectic between body and soul, matter and mind; the image represents the possibility of coming out of bodies and souls without becoming another body, without entering into the consciousness or the soul of another being, without transforming itself into the actual perceptions of someone else.

It is as if, for every form, there were a life beyond the body in which that form stands [*insiste*], a life that, however, foreruns the "life of the mind," because it exists *before* entering into the realm of minds, of souls, of consciousness [*coscienze*]. The image is born and always lives after the end of the body of which it was the form, its final boundary, its surface, but always *before* the consciousness in which the image is again received and perceived.

> *Quid est ydolum? Dico sola apparentia rei extra locum suum ... quia*
> *res apparet non solum in loco sed extra locum suum.*

The mirror is the perfect incarnation of this metaphysical, intermediary space between bodies and souls. It is precisely in this place and time that forms *make themselves sensible*.

How, then, can we define an image? In his work on perspective John Peckham held that an image is "merely the appearance of an object outside its place (*extra locum suum*) because the thing appears not only in its own place but also outside its own place."[1] The Being of images is the Being of forms existing in a foreign matter, which is different from their natural and ultimate substrate. Our image is nothing but the existence of our form beyond what makes us up, the substrate that permits this form to exist in an entirely extraneous matter to that in which one exists and mixes with. Every form is born from this separation of the form of a thing from the place of its existence: *Where the form is out of place, an image will have a place [ha luogo].*

Any form that can cease to be in its proper place, and which is able to exist outside of itself, can become an image. Being an image means being outside of oneself, being a stranger to one's own body and soul. Our form acquires a different being from its natural one, a being that the Scholastics referred to as *esse extraneum*, the extraneous being, the foreign being. The being of the image is the being of extraneousness between body and mind. In other words, forms are capable of passing into a state that corresponds neither to the natural being that they have in their corporeal existence (physical, mundane) nor to the spiritual state in which they find themselves when they are known or perceived by someone. For every form, becoming an image means to experience this painless exile from its own place, in a supplemental space that is neither the space of the object nor the space of the subject, but rather one that derives from the first (the space of object) and supports and makes possible the life of the second (the subject).

Thus, an image is defined by a dual exteriority: the exteriority from bodies—because the sensible is generated outside of these—and the exteriority from souls—because images exist *prior* to meeting the eye of the subject who observes a mirror. Every sensible being, therefore, is not only *extra-mental* but also *extra-objective* or *extra-real*. Each sensible being defines a

system of existence that is different from that of bodies, souls, and minds. Existing in a different way from the one of objectivity, images lay the foundations, on the one hand, for what we call fiction, and on the other hand, for the possibility of error. The error is possible because the image (the Being of knowledge) is transcendentally exterior to soul and things.

Aristotle wrote that the sensible being is something individual and is always "externals" [tōn exōthen], not only exterior to things but also, more important, exterior to the soul and to living beings capable of perceiving the sensible.[2] A long tradition had opposed the body as the form of exteriority to the soul, the place of interiority. From Augustine until Kant space, the world of bodies, is the form of exteriority, "the form through which everything happens that is exterior to us," and "the form through which everything that is exterior to itself occurs,".[3] In this tradition, space is the world of the *partes extra partes*, the place in which everything exists outside of itself and other parts. Thanks to this double exteriority, the image is the absolute exterior, a hyperspace that holds itself outside of the soul as well as outside bodies. The Outside, then, does not coincide at all with the world, with objectivity, with bodies: The extreme boundary of exteriority is populated by only images.

8

THE IMAGE IN THE MIRROR

The sensible is the Being of forms when they are outside, in exile from their proper place. But what form does this "outside" have? In which way should we describe this supplemental space that is the absolute outside with respect to our souls and bodies? In order to grasp this, we need to investigate the properties of this *extraneous matter* in which images spring, are born, and live. How does our form truly exist in the mirror? What is, then, the way of existence of a form in a matter that is foreign to it? And, in general, what is the "being-in-the-world" that is defined by a mirror?

Inasmuch as they are foreign to corporeality, images exist nonspatially. Albertus Magnus wrote that when a mirror receives our image, it gains neither weight nor volume (*speculum propter ipsam non occupant maiorem locum*).[1] If a body has profundity, the image exists in a mirror without raising

Forma illa resultans in speculo non habet illas dimensiones, sed tantum speciem et intentionem illarum specierum. . . . Imago resultans in speculo non habet longitudinem et latitudinem, secundum esse longitudinis et latitudinis, sed potius speciem et intentionem illarum dimensionum habet tantum. . . . Si enim esset longum vel latum cum longitudo illa vel latitudo non terminetur secundum terminos aeris vel speculi sed aspicientis oporteret quod longitudo et latitudo alicuius esset extra ipsum, quod est inconveniens. Et propter hoc necesse est dicere quod in veritate non est longum neque latum, sed species longi et lati per quam cognoscantur figura aspicientis.

itself above its surface. The being of the sensible, the imaginal being, as that which relates to the image, does not therefore define any spatial existence. We saw already how an image is a form's escape from the body of which it is form—without this exterior existence becoming *another body* or *another object*. The image is the form inasmuch as it lives *in another body* or *in another object*. Objectivity, corporeality, is now its place, its substratum, and not one of its essential features.

All of this suggests that the presence [*inerenza*] or the immanence of an image in a mirror is no longer defined *essentially* by quantity. This was proven, as medieval philosophers had already shown, by the fact that, when you break a mirror into ten pieces, we find within each of the fragments the entire, nonfragmented image (*si speculum frangatur in decem partes, in qualibet illarum partium erit forma tota*). Furthermore, the image in each of the pieces of the shattered mirror is no smaller than it was when unbroken. The image, the sensible, therefore has the capacity to rest against matter, on the medium, but not broadly: Its presence does not depend upon the extension of the latter. It would be more correct to say that the image is that being which, without being devoid of extension and without being nonextended and incorporeal, maintains a completely accidental relationship with size and bulk. For this, as Carroll will demonstrate later, a quantitative variation of the image will never alter its nature, which is quite different from what happens on our side of the mirror. An image may increase or decrease in size; it will continue to be incapable of dividing itself, shattering or separating itself into parts. The sensible is the intensity [*intensivo*] that lies gently down upon extensionless spaces in a purely accidental manner. Thanks to this ability to be in a place, but not according to the manner of extension, images are everywhere: in the air, on the surface of the water, on glass, on wood. They live as on the surfaces of bodies, but they are not to be confused with them. A melody lingers [*insiste*] in the air, coincides in some aspects with a quality of the air itself, with its vibration, but it is not in the least bit reducible to air. The existence of the sensible is not determined by the capacity of a specific matter but rather by the capacity of the forms to exist outside of their own natural place.

This characteristic lends another paradoxical trait to the imaginal being: even if an image insists on its own substrate *ut in puncto* (thus, in a nonextensive manner), that is, it exists in the mirror as if it occupied but one point, it

Generatio forme intentionalis . . . in tribus differt a generatione forme
realis: primo quia in generatione formarum intentionalium generantur
formae sine propria materia; secundo quia generantur sine contrarietate
materie; tertio quia generantur sine distractione et impedimento
materie. . . . Non enim fit huiusmodi generatio sine omni materia, nam
licet non fiat in materia propria, fit autem in materia extranea. Unde
intentiones colorum ut vult Commentator in libro De anima non habent
esse naturale sed extraneum, quod sic intelligendum est: quia sunt tales
intentiones in materia propria et naturali ipsi colori cuiusmodi est cor-
pus terminatum idest corpus quod est terminatum visus, sed fiunt in ma-
teria que est extraena ipsi forme coloris cuiusmodi est materia pura et
dyaphana. Rursus generationes talium formarum non sunt sine materia,
quia cum conditionibus materie; recipit enim talis forma hic et nunc. Est
etiam et tertio generatio talium formarum cum materia, quia est secun-
dum situationes partium materiae, ut si coloratum aliquid imprimat
suam intentionem in medio pars dextra illius colorati impressionem
dyametralem et fortem faciens in dextra parte medii et pars sinistra in
sinistra, que omnia arguunt generationem talium formarum esse genera-
tionem cum materia.

maintains the form or the appearance of the dimensions of a natural
body. It is not long, wide, or deep, but it maintains the appearance of these
dimensions, and it is their *ratio cognoscendi*. It is for this reason that a
mirror is able to concentrate in itself the form of things that are much
larger than it.

Scholastic philosophers argue that the life of images in a mirror defines
a form of existence that is completely insubstantial. In receiving the image,
a mirror changes neither identity, nature nor substance. It does not change
in the least. Its being [*essere*] remains unaltered, stable, identical. The form
reflected in the mirror, however, is still something. What, then, is its man-
ner of being? Even if it is not a substance, is it legitimate to think of it as
nothingness? In a wonderful chapter from his *Summa*, Nicholas of Stras-
burg tells of those who would reduce images to pure nothing (*nihil est*
absolute), or to the simple relation of the mirror with whomever observes
it. For his part, Nicholas claims instead that the being of the sensible, the

being of an image, is not and cannot be considered pure nothing or a purely relative fact. The image will continue even if no one looks upon it. The genesis of the image is not a transformation of the mirror. Something is added, however, something that if removed would not produce any substantial change. The image, Nicholas concludes, is a purely accidental being, supplementary, but it remains something more substantial than the gaze that falls upon it.

9

MICRO-ONTOLOGY

Mirrors remind us that there are images, that *there is the sensible being in the universe*, and that images are not a property of things; nor are they an accident of a consciousness or belong to the realm of animality. They are, rather, a *special being*, a sphere of the real that is separate from the other spheres; something that exists in itself and possesses a particular way of being, whose form it is urgent to describe. This explains why the science of the sensible is a form of regional ontology, capable of positing *another kind*

Esse intentionale potest dupliciter accipi, uno modo prout distinguitur contra esse reale et sic dicuntur habere esse intentionale illa quae non sunt nisi per operationem intellectus sicut genere et species et logicae intentiones; et iste est proprius modus accipiendi intentionem et esse intentionale. . . . Alio modo dicitur aliquid habere esse intentionale large, quia habet esse debile sed habere esse debile adhuc tripliciter. Aliqua enim dicuntur habere esse debile quia non habent suum esse simul sive permanens sed in successione ut motus et tempus et haec non dicuntur habere esse intentionale. . . . Secundo modo dicuntur aliqua habere esse debile quia ad sui existentiam requirunt praesentiam suae causae proximae naturalis, quod pro tanto dico quia angeli et ea quae immediate a deo producuntur requirunt ad sui existentiam potentiae suae causae immediate (scilicet Dei) et tamen non dicuntur habere esse debile. . . . Tertio modo dicitur aliquid habere esse debile non solum per comparationem ad causam proximam naturalem sed quia deficit a perfectionem propriae speciei.

of being, the being of the images beyond the being of things, of mind and of consciousness.

Scholasticism has long wondered about the principles of this "special ontology." Medieval theologians held that images had a *minor* being, inferior to the thing of which they are the image. Their being is extremely weak (*esse debile*) as Durandus of Saint Pourçain wrote. At the beginning of his work on optics, Roger Bacon had instead noted that an image "is called 'intention' by the multitude of naturalists because of the weakness of its being in comparison to that of the thing itself, for they say that it is not truly a thing, but rather the intention, that is, the similitude, of a thing."[1] In addition, Avicenna had already written that "intention has a lesser being than its object has."[2]

To speak of images therefore means to engage in micro-ontology; that is, to speak about the weaker and more fragile form of being which exists in the universe. For this reason the first difficulty, aporia, or problem that must be solved for this new science consists in determining the differences between the genus of Being respectively of things, objects, and images. Johannes Buridanus lamented in his commentary on Aristotle's *De anima* that the difference between what we call the real or bodily being and what we call spiritual or intentional being is very unclear.

Placing the real being in opposition to the weak, minor being of images is not a way of dealing with what modernity has come to call the imaginary. In one of his comments on Aristotle, Averroes will say that the being of images is something in between the being of things and the being of souls, between bodies and spirit.[3] Forms that exist outside of the soul have a purely corporeal being, while those that exist within the soul have a purely spiritual being. The being of images is necessary for this very reason, continues Averroes, because it constitutes but one element that permits nature to pass from the spiritual to the corporeal domain and vice versa. In order that the spiritual can grasp and take possession of the corporeal, a middle term is necessary.

Et esse formarum in mediis est modo medio inter spirituale et corporale: forme enim extra animam habent esse corporale purum et in anima spiritualem purum, et in medio medim inter spirituale et corporale. Et dico medium in hoc loco instrumenta sensuum et ea que sunt extra sensum.

10

TRANSPARENCY

There exists a place in which images are born, a place that must be confused neither with the matter in which things take shape nor with the soul of living beings and their psychic life. The specific *world* of the images, the place where everything is just sensible (the original place of experience and dream), does not coincide with the space of objects—the physical world— or with the mental paradise in which all knowing subjects come together. This third space cannot be defined either by the capacity to know or by any other specific nature. A *medium* is not defined by its nature or by the matter that constitutes it, but rather by a specific potentiality that is irreducible to both.

The image, as said earlier, is the existence of form deprived of its matter. To be a *medium* means being capable of receiving forms immaterially. Mirrors "receive" images, the air receives sounds, but this reception cannot be interpreted in terms of a mere material transformation. It is as if the space that is capable of receiving these small supplementary beings that are the sensible images, would contain within itself a sort of *supplement of being*. A medium is a being that has within itself a supplement of being, another space that is different from what is produced by its nature and its matter. This space, Averroes argued, is *reception itself.*

quia diaffonitas non est in sola aqua neque in solo aere, sed etiam in corpore celesti, fuit necesse ut diaffonitas non sit in aliquo eorum secundum quod illud est illud quod est, v.g. secundum quod aqua est aqua.

In fact, each medium is a receptor, and every theory of mediality must lead to a theory of reception. Reception, Averroes writes in a difficult and very profound formula, is a particular form of passion that does not imply a transformation (*passio sine transformatione*). Normally, when a form enters the material density of its receptor, the form is changed and changes in turn its own receptor. In this instance, we have simple transformation. The process through which a sensible form is received in the medium cannot be reduced to a phenomenon of a material or a qualitative transformation of the substrate. The screen that receives the images in a cinema does not undergo a physical transformation, in much the same way that the birth of J.M.W. Turner's watercolor paintings are not the process of a chemical transformation of the canvas on which they lay. In the same way that a mirror is "affected" by an image without undergoing a transformation, so, too, does every image constitute itself through the nontransformative passion of the medium.

Mediality, therefore, is not a physical property of things; it does not perfectly correspond with any of the bodies that populate the world, though it can dwell within them all. It consists in the ability to be affected by something without being transformed and without transforming the thing that affects it, almost like a passion without the suffering or resistance. If the sensible exists and if images exist, it is because there is this hidden, supplementary power between things, the receptive faculty. And this faculty is absolutely devoid of organs, because it is not defined by a matter, a form, or by something positive. On the contrary—and this is the second property of all media, according to Averroes—that which receives must not enjoy the same nature of what it is received; the receptor therefore must find itself in a state of privation of the nature of the form it receives. Every medium, every receptor, is such thanks only to its own ontological void, that is to its capacity not to be what it receives. This is clear enough in the medium par excellence, the medium capable of receiving light itself: transparency, the diaphanous. It is due only to its invisible, uncolored thickness that transparency can receive light and color. Transparency is not a specific body: neither water nor air or ether, but rather a common nature without name (*natura communis sine nomine*) that is present in all of these bodies. In the words of Averroes, transparency does not exist in bodies according to what they are, that is according to their nature. A receptor receives *in spite of* its form and *in spite of* its matter; it is never defined by a specific nature, for

the very reason that it is nothing more than the capacity to not be what it can receive. It is for the same reason that any body, any entity, can become a medium: air, water, the mirror, the stone of a statue. All bodies can become the medium for another form that exists outside of it insofar as it can receive this form without offering any resistance to it.

11

THE MULTIPLICATION OF THE REAL

The world of images, the sensible world, is one constructed upon the limits of a specific power, the receptive power. The medium separates the forms from their original substrates and natures, and it gathers them within itself in their immateriality. In scholastic terminology, the medium is the place of abstraction (*abstractio*), that is, of separation: The sensible is the form insofar as it is separate and abstract from its natural existence. Thus, our image in the mirror or in a photograph exists apart from us, in another matter, in another place. Separation is the essential function of the place. To give place to a form, to mark it with a *hic*, means separating it from the others, to divert it from the continuity and the mixing with the rest of the body.

This medial separation of images that takes place in the sensible is made possible by a form's specific property of multiplying itself. One often considers the experience of the duplication of one's own image in the mirror as a tragic experience of disassociation between the self as subject and the self as image, or as the irreconcilable split between the self and the idea (or ideal) of the I. These petty fears, which are theological more than philosophical, make one overlook the essential feature of this phenomenon. There is something comical whenever one looks at oneself in the mirror— or every time one catches sight of oneself from the outside, every time one pictures oneself as different from what he or she actually is. The mirror, the imagination, the surface of water upon which we are reflected has not deprived us of our form. It has simply multiplied it.

Images (and therefore *media*) are *the agents of the multiplication of forms and truth*. The formula of the *cogito* of images that we have laid out must

then be corrected. While I look at myself in the mirror I am, in fact, observing myself here *and* there *at the same time*; on this side (in me) as body and soul, and within the mirror as a sensible image. Becoming an image is both an exercise in relocation and dislocation, but moreover in *multiplication* of self. One appears and exists within the mirror for a moment *even* when one no longer lives or no longer thinks; to be mirrored means to feel the thrill of existing in multiple places at the same time and in different manners. Every morning, when our body passes in front of the mirror, our form exists in four different ways: as a body that is reflected in the mirror; as a subject that thinks and experiences; as a form that exists in the mirror; and as a concept or image of the soul of the thinking subject, which allows the subject to think its own self. The existence of the sensible in the world demonstrates just how ineffective Ockham's razor is.

The sensible is the multiplication of being. One may argue whether just a single world exists or if there are infinite ones. In fact, the existence of images infinitely multiplies the objects of the world within *the very interior of this world*. It is no coincidence that the technical title of the works on the physics of images in the medieval ages was *De multiplicatione specierum*, on the multiplication of forms. The sensible image allows things to access the realm of the innumerable. From the moment in which the sensible exists; from the moment in which images are born—forms cease to be unique and unrepeatable. In this, technique does not carry out a specific role. *The reproduction of forms is the natural life of images.* So, too, is thinking—the psychic life of the sensible—a form of multiplication. Speech, hearing, sight—all of our experiences are an operation of multiplication of the real. To hear, speak, think, see, draw: thanks to the sensible life (and within it), all the things of the world (and the world itself) never cease to live outside of themselves, to reproduce, to multiply.

12

THE PRIMACY OF THE SENSIBLE

Mirrors and their dynamics guard the secret of the sensible life: An image is never reducible to the act of perception or to the existence of the thing. An image is always something that is out of place. Indeed, it is the very being out of place of the world and of things. The sensible life, the life that every image stores within itself, is this possibility of an extreme delocalization. And vice versa. The sensible life is possible because forms have this curious ability: that of being constantly out of place.

This topological paradox, which we have established, extends into an ontological anomaly. There seems almost a priority of the image over the imagination, a priority of the sensible over sensation and perception. This is not only a chronological priority. There is sensible life in the universe because images exist and because a kind of being exists that is distinct from that of the things and souls, of the psychic and the material.

It is for this reason, too, that perception should be tackled from the point of view of the image and not from the subject that perceives it. In his last and very dense work, Merleau-Ponty recognized the necessity to "be placed back in the 'there is' [il y a] . . . upon the soil of the sensible world."[1] This primordial base, this ancestral place of the sensible (the soil of the sensible), however, corresponds for him and for a large part of the phenomenological tradition with "our bodies . . . this actual body I call mine, this sentinel standing silently under my words and my acts."[2] It is as if phenomenology, though it affirms the priority of perception over consciousness, it is not able to grasp the Being of the sensible independently from the Being of the subject, of the soul that perceives it. Merleau-Ponty emphasizes in an early text that perception "does not exist except in the measure in which some-

one can apperceive."[3] Every image therefore would exist only because there is a soul behind it to perceive it, or which is in the act of imagining thanks to the image. Hence, there would be the sensible only because there are living beings in the universe (man or animal, because here distinction plays absolutely no role).

To make the image itself the center of the sensible life means overturning this perspective. By the opposite token, it is thanks to the visible that vision is made possible, and it is music that makes listening possible. In the words of the greatest of Aristotle's commentators, *visio est posterius visibili*: vision is something which follows the existence of the visible as such. To paraphrase Merleau-Ponty, one could speak of a priority of the sensible over sensation and of the percept over perception. This is not a simple dialectical reversal: The priority of the sensible, is, in fact, founded on a specific ontological homogeneity between the medial space and the cognitive space. There is no *substantial* difference between the medium and the perceptive organ: an organ is an embodied medium. According to Averroes, everything that has a place in the soul also has a place in the medium (*et hoc non tantum invenitur in anima sed in mediis*). This does not mean that the medial is a modality of the mental or the cognitive: On the contrary, what today we call the mind, the spirit, or cognitive reality are actually nothing more than a specific modality of medial reality, a sort of "animated medium." It is the medium, therefore, that permits us to understand what is the mind and not vice versa, in the same way in which the mirror is the archetype of every perceptive act. In the depths of our sensory organs images find only the possibility of exercising their own influence, to produce additional movements within the bodies that host them. What separates a sensory organ from an exterior medium is only its natural connection to an organ of movement.

It is not the eye that *opens up* the world: Light exists before the eye and not within it; the sensible exists before and indifferently from the existence of any perceptive organ whatsoever. If the universe contains the sensible, it is because there is not a single eye that can observe everything. It is the

sensible that paved the way for the existence of life, just as every day it is the sensible that reopens the world to the bodies and the minds that inhabit it and think of it. *Sensible life* is not the laborious physiology of the sensory organs, and it is not guarded within the structures of organized bodies; its borders extend as far as an image can reach, and its physiology is extracorporeal, extramental, and extraobjective.

13

NATURAL THEATER

The world is not *essentially* phenomenal. Things are not the sensible: They need to become visible, tangible, audible, and they become so only outside of themselves. The world and everything in it, therefore, are and become appearances—that is, *phainomena*—only elsewhere with respect to the place in which they exist, and thanks to a matter that is not the one that they are made of. This place in which reality makes itself knowable and phenomenal is a nonobjectual space and not necessarily psychological; it is designed by the mobile geography of *media*. Only in *media* and thanks to *media* can the world become a phenomenon. If this is true, the phenomenological project, which has engaged philosophy for so long, should be immediately laid to rest. Strictly speaking, there is no phenomenology: there is only a "phenomenotechnique." The things of the world, in fact, *must* be made sensible: the must be transformed into images. And *media*— regardless of their nature of objects, natural organs, or artificial realities— represent the natural technique of transforming the world into phenomenon, into sensible reality, image. Indeed, every act of knowledge, every form of experience for any living being is what results from the relation of contact and contiguity (*continuatio*) with this intermediary space, and it is the result of a medial contiguity.

Medial space is a secret natural theater where everything comes to manifesting itself; it is a stage that is in constant movement, opening the world to another life, a life that is different from the life that everything has in matter and in minds. The medium is a fragment of the world that allows for forms to extend their life beyond their nature and beyond their material, corporeal existence. This supplementary and receptive space does not

derive from a specific nature that is elementarily separate from the rest of natures, but it is an immaterial and nameless power, shared by all bodies. It does not coincide, however, with the spiritual or the psychic: if the psychic is the embodied form of the medial, the medial (the imaginal) is able to exist beyond the psychical.

The sensible (the phenomenal existence of the world) is the supernatural life of things—the life of things beyond their nature and beyond their physical existence. It is simultaneously their infracultural and infrapsychic existence. Images possess nothing that is exclusively anthropologic or cultural, in much the same manner that they possess nothing that is merely natural. The sensible is beyond any and every opposition between nature and culture, life and history, in the same way that the medium is beyond any and every inane dialectic between subject and object. Every medium opens a supplementary space that exceeds the nature of bodies (it goes outside of them) and opens an ontological interregnum that, for a moment, resists the interiorization of culture. Supermaterial and precultural, the world of images (the sensible world) is the place in which nature and culture, life and history exile themselves in a third space. Media hinder the world from closing in on itself in its own nature and truth, making forms plural, making the world exist beyond itself and multiplying its life on this side of its self-consciousness.

14

THE UNITY OF THE WORLD

We live under the perpetual influence of the sensible: odors, colors, the flavor of the food that nourishes us, the melodies and the most commonplace sounds are the very first causes, the ends, the unceasing occasions of our gestures. Our existence—whether sleeping or awake—is a relentless stream of the sensible. All of the images with which we constantly nourish ourselves, ceaselessly feeding our waking and dreaming experiences, define the reality and the sense of each and every movement we make. They provide reality to our thoughts and a body to our desires. We cannot measure the limits of animal life on the borders of its anatomical body: Animal life—that is, life shaped and sculpted on the sensible and by the sensible—reaches there, where images reach. A world without odors, sounds, music, and colors, a universe where things and forms would no longer be capable of living outside of themselves in order to reach living beings, and thus live—in intentional form—within them, influencing their every movement, would lose any consistency whatsoever. This universe would become a mass of petrified reality, whose only reciprocal relationship would be determined by external forces—gravity or centrifugal force.

The world conspires to be something united only because of images. The connective fabric between things is produced by *media*, which represent the condition of the possibility for the existence of the sensible, building the continuity between subject and object and putting the two spheres of the psychic and the material, of "culture" and "nature," into communication. As Aristotle demonstrated, subject and object—mind and body, thinking and matter—do not communicate immediately; if one is put in touch with the other without the interaction of a *medium*, neither of the two is able to

act upon the other. They can enter into fruitful contact, act upon, and recip-rocally influence one another only because of the existence of the *medium*. *Media* are what produce the continuity between mind and reality, between the world and psychism. In a world devoid of *media*, objects would be locked down in their own aseity, and living beings would be condemned to lead an acosmic existence. Thus, they would seem trapped within their own void interiority, in the impossibility of being affected, truly *touched* by things, or able to host within themselves all of that brilliance and minor life pro-duced by intentional forms and the images of the world that is the most authentic body of animal life.

Media in the cosmos, therefore, produce a *continuum* in which the living and their environment become *physiologically* inseparable. Media are the place in which nature fades into spirit and culture, the prosthesis through which rationality accesses objectivity. On a cosmological plane, one could say that media embody the same role that, according to Kant, transcen-dental schematism had in the life of the subject. The sensible carries out a similar function in this world: Thanks to images, matter is never inert but always malleable and full of form, and the mind is never purely interiority but technique and mundane life. It is harmful, then, to reduce the sensible life to the psychological; images have a *cosmological* function, not merely a gnoseological or physical one. Images are the true cosmic transformers that allow for the spiritualization of the corporeal (or its animation) and the embodiment of the spirit.

For this reason, the world finds its unity only in images. That unity is not merely *physical*, that is, produced through physical contact or the com-bination of its components; nor is it merely *spiritual* and thus existing *out-side* of the world in an otherworldly intellect or in a transcendent Unity [*Uno*] beyond being and substance, as ancient Neoplatonic thought had

> *Nam anima universi assimilatur ipsi actui imaginativae: in se quidem simplex et individua; at imago prototypa totius universi quam qui cer-neret, omnia producibilia in chao seu materia eidem a creatore subiecta intueretur, se ipsam vero exprimit eodem modo quo phantasma in cere-bro: hoc est ideam confusam et involutam totius universi; ita ut re vera omnia.*

suggested. The unity of the world is not physical, spiritual, or metaphysical, but always and only *medial*. In other words, the universe is one, and it remains so not because there was a single and unique cause (what scientists today call the "big bang"), but rather because a medial space exists.

The relation that holds all things together in unity in the *same* cosmos is not the process of physical transformation that leads to the homogeneity of a single matter; neither is it the simple spiritual comprehension that transcends the multiplicities of forms in the unity of the thinking subject. If things come together [*simpatizzano*] or "conspire" to form a single world, if things maintain a close-knit network made not of spiritual or physical relations alone, it is because it is through images that each thing exerts *influence* over the others.

Anthropology of the Sensible

15

VITA ACTIVA

Sensible life does not flicker out the moment that the perceptive act ends. The sensible lives *before* us and continues to live *in* us after perception. It lives almost as the background murmur of every one of our thoughts, as the living fluid of every memory, as the ultimate horizon in which every project and all of our activities take shape, becoming realizable, if not real. Furthermore, all living beings do not limit themselves merely to *receiving* the sensible: They never cease to produce the sensible. In this aspect, man overtakes all animals: He speaks, produces smells, designs, and schematizes.

The life of animals is not tied up to the sensible in a merely passive way. Each animal feeds on images and can survive only thanks to them, but at the same time the animal—in everything it does—gives back the sensible to the world. The existence of any superior being is characterized, for example, by the existence of an immediately embodied form of sensible on its own body: It is what occurs in the skin of animals or the clothes of humans. In this case, the animal body becomes the medium that transforms the animal itself into an image. An animal body is also characterized by a perpetual flow of *sensibilia*, of sensible life capable of living beyond its anatomical borders. To live, for an animal, means giving place to autonomous, multiformed images, images that are utterly independent of the anatomical body.

And so it is for man, but with a greater degree of complexity when compared to animals. A large part of the operations that anthropologists usually archive under the column "spiritual activity" or "cultural activity" not only takes the sensible as object, but also has no other consistency than a precise form of the sensible. Figurative art, literature, music, and a significant portion of political rituals and the totality of religious liturgy consist,

The task of an esthesiology of the living body is to know the specific ways of incarnation of our own bodies, a very particular actualization that has a somewhat elementary and somewhat refined meaning. . . . From the incorporation in acting and dancing to the exhibition that veils and unveils in clothing and ornaments, from dietary habits up to techniques for self-control and disincorporation, from the simplest of games to the most specialized of sports, this theme has a vast array of variations and provides different starting points for analysis. The main theme is given by refined comportment, by the irreplaceable role of the sensible modality required by its incorporation. Thus, setting off from the modality of incorporation, one attempts to retrace the individuation of laws that preside over the ways of appearance in the surrounding world. This surrounding world gets adapted to our particular behavioral modality, yet this does not imply that these modalities are any less open, therefore, these modalities infringe upon every pattern of animal action, and they are not measurable according to any simple biological principle of relativity of senses from actions, in the same way that they tirelessly contribute to the nourishment of the organism, or better putting it in question under every aspect.

first of all, in the production of forms of sensible. All of our customs and habits become incarnate in a sensible that is disembodied from our anatomical body. And, vice versa, any object of material culture (technical, industrial, artisanal) is nothing more than a sensible embodiment, a "sensification" [*sensificazione*] of will, subjectivity, and spirituality. Man, first and foremost, does nothing but transform the spirit and his rationality into the sensible. We are not human only because we are capable of abstraction, of distilling rationality from the empirical, of sublimating our experience. Above all, writing, speaking, even thinking, means moving in reverse: finding the right image, the right sense that permits us to realize, and withdraw from, what one thinks and feels.

Above all, living means giving sense, *sensifying* [*sensificare*] the rational. It is transforming the psychic into an external image and giving body and experience to the spiritual. Each gesture in which animal existence is articulated exudes the sensible. Only in this sending out of the sensible can the spirit and "culture" of a people produce itself. The failure to remember

this fact is due mainly to a great misunderstanding around language. One forgets that language is, first and foremost, one of the forms of existence of the sensible. If we speak, it is because we are particularly sensible to images. No language exists without images; language is a superior form of sensibility. Actually, we can understand language as the archimedium, a space of absolute mediality where forms can exist as images that are completely autonomous from speaking subjects, as well as from the objects whose form and aspect they are supposed to represent. There is no need to think of spaces without words in order to demonstrate the presence of the sensible within human, spiritual productions.

If material culture (what is objectified in artifacts that are produced and exchanged) and spiritual life are supreme expressions of the sensible life, it is because "spirituality" and "culture" do not spring from the relation of subjects to themselves, nor from the immediate tension between spirit and nature, body and soul. Each of the forms of our interior, spiritual, and superior life, including individual or general will, takes shape and can exist only in something *sensible*, capable, therefore, of standing beyond the subjects that have produced them, beyond the closed circuit of interiority, without becoming a thing, a mundane object. To socialize something often means simply making it sensible, giving it the appearance of something that can be perceived, that is making it live off a sensible life. Alternately, to sensify is already to share, to bring to the many what only existed privately.

Drawing, schematizing, graphically representing, and other similar operations all guard an important problem, one that Kant touched upon in his chapter on transcendental schematism in *Critique of Pure Reason*. Here, with the aim of researching the possibility of an exact description of nature, the scheme appears as an intermediate element of correlation due to the applicability of categories of sensible intuition, and specifically as a representation of a method that makes the originary formation of images . . . Are there not perhaps other methods of mediation, condensation, or objectification similar to schematization asked of the imagination? And isn't that what in fact happens when ideas are made real in an artistic or practical-political sense?

The ability of living beings (to a degree and in forms which are different in each forms of animal life) to produce the sensible and to transform their own psychism in images is made possible by medial space. Schematizing, designing, representing, but also singing, speaking or simply appearing or communicating: Our more refined life takes place in this space and acts within it. All these activities are not purely psychological realities, or simple expressions of interior psychism; if this were so, they would not come out of the *camera obscura* of our consciousness, and no one besides the unnamable guardian of our unconscious would be able to retrace their steps.

Everything takes shape and *must* take shape in the sensible. The first space in which the spirit objectifies itself is not the reality of institutions, and it is obviously not the hard matter of elements that make things, but it is the medial space. Living beings do not use the sensible only to apprehend and develop consciousness of our natural bodies and the world that surrounds us. It is, in fact, only through sensible mediation—and never directly, never immediately—that a living being *acts* on things, builds a *specific* environment starting from the surrounding world, interacts with this, influences objects and other living beings outside of itself. We have often stated that the very same body of an animal is shaped by the sensible, oriented toward the sensible, sculpted by the sensible: Its openings, its different breaches serve, first of all, to allow the sensible to penetrate; its forms allow the sensible to act on it in the most convenient way. But it is also true that every animal life sculpts and shapes the world that surrounds it, and it can exercise on it a certain influence only by means of the sensible, which it is capable of producing across its whole body. Everything within the living is destined to produce the sensible: from the skin to the brain, from the hands to the mouth, from the possibility of carrying out gestures that can be seen as the capacity to emit sounds or smells that allow for the modification of the world.

16

THE SENSIFICATION OF THE SPIRIT

The project of modernity has long since expressed itself in the stubborn pretension to see the human spirit achieved only through the material production of objects and their exchange (material culture), through the complex system of reproduction of the conditions for biological existence (what the Marxist tradition called labor), or through the capacity to speak or, better, the tautegorical emanation of humanity and social substance objectified in law, institutions, customs and ethics (the Hegelian *objektiver Geist*). According to a renowned tradition, in these realms life not only becomes truly human, but it also opens for the first time to a common, public sphere—a *political* sphere in the fullest sense of the word. In the end, one often considers that it is in these spheres that human life secretes and becomes *culture* for itself, hence taking leave from the exclusively biological dimensions of its existence and achieving what nature is unable to realize in any of its multiple expressions.

It would not be difficult to demonstrate how this tenacious belief cannot be completely divided from the role that, in the history of Western anthropology, has been assigned to the sensible life, which is so often reduced to an ephemeral, uncertain, and entirely private form of individual psychism. It would seem a steep task indeed, to find something specifically *human* in such a common and indeterminate dimension, shared with an infinite number of other forms of life, all of which are themselves infinitely diverse in their ethos, habits, dimensions, and antiquity: To become man would signify being able to access an additional life. And it would be just as difficult to deduce the foundation of the common, of a life lived together with

others, from a purely individual disposition [*disposizione*], which is neither social nor socializable in itself.

Yet our *vita activa*, that is, the most proper form of life, the *spirit* that should make us superior to all the other animals, seems to begin already in the images with which we appropriate the world and its forms. The very same spheres through which we live *humanly*, *politically*, and *culturally* are not, in fact, separate from the sensible life, but are grounded in it and *only* in it. If we were pure spirits, we would have no need of culture. If our humanity truly coincided with being separate minds from bodies and already replete with forms, we would have no need to worry about regulating our lives through institutions. If we were acosmic brains immersed in a vat, we would not need care about producing objects in which to mirror our experience. Our existence begins and persists in the sensible life until our very last breath and our very last thought.

The sensible life persists for profound reasons. In relating to the world, in our *being-in-the-world*, we do not live, in fact, in a purely material way as a "thing among things," or as an incorporeal mind ideally joined to all the other minds and ideas of things. It is in the sensible life that we encounter and maintain relationships with others and with the world, and everything (man, animal, things, and ideas) is given to us in the form of an intensity of sensible life. We ourselves *are*, first and foremost, an atom of sensible life for everything that surrounds us.

The relation of the living to the world, then, is not purely ontological nor is it merely poetic: It cannot be reduced to the verb "be" or the verb "do." The living human *is* [*sta*] not in the world in the way that a stone exists; neither is it limited to having direct relationships of action and passion with the world. This is because the living being relates with things medially, that is, through the sensible that it is capable of producing.

Even language, the most spiritual of activities that the anthropologist usually credits to man, consists in commerce with the sensible. Language is not a way of doing or a way of being; it does not entail an immediate relation with things, nor is it a simple relationship with oneself. It is, rather, the relation with a special medium that *makes* the sensible *exist*. The misconceptions that modern anthropologists have so often defended, spread, and maintained have hindered the recognition of the true nature of this activity, which is superior to production and work, and inferior to political action or ethics.

Sensible life is not only the *place* of the realization of the spirit and its very first body. It is also the object on which culture, work, language, and institutions exert themselves; it is the matter from which and in which the "spirit" must find and produce its own forms. A large portion of the political, social, and cultural processes in which we decide the forms of our human being has the sensible life as its place and object. Fashion demonstrates this, since it is through fashion that the way in which we are sensible for others is socially defined. By contrast, it also demonstrates how one of the most urgent, constant, and precise activities of any society is to define the way in which each of its members must be perceivable by the rest.

Therefore, our "better" life cannot really be defined abstractly through work, action, or communication. The living being can neither be defined as the one that operates on things: any natural object has the capacity of immediately acting upon things. Animal life, first of all, is neither work nor action, but rather *sensible life*. And what characterizes the *living* human—just as it does for all *animals*, although in a different way—is the capacity to produce images of things: neither a *praxis* nor a *poiesis*, but an intermediary sphere of commerce and production of the sensible. We are not concerned here with the faculty to embody forms into objects, but the ability to make them momentarily live outside of things and outside of subjects. Projects, designs, music: A large part of human spiritual activity lives primarily off this capacity to make forms linger in *media*, before they reenter the world of things. It is not just thought, that is, the ability to have ideas capable of moving one's own body that defines *human* life, but the strength to free these ideas, that is, to make them have a life on their own and the ability to bring them into a medium. Similarly, what distinguishes an animal from a plant or an inanimate object is not the capacity to cause effects, to act immediately on things, but the faculty to *produce* (and receive) actively and willingly the sensible.

The "spirit," therefore, objectifies itself, above all, in the invisible day-to-day commerce that it passively and actively holds with natural and artificial *media*. In the same way in which it is only through the mirror that we can experience ourselves, it is only through *media* that our spiritual existence is able to extend outside of us. Only through images can we give form to things and succeed in penetrating other living things. Thanks to the sensible (that we are and that we produce) we can push beyond our subjective sphere, and live "in others," exercising influence over the world

and other living beings. In producing the sensible, we produce effects on reality insomuch as we are living, and not because we are simple portions of extended matter or quantifiable physical forces. Through our appearance—the sensible that we actively or involuntarily emit—we make "impressions" on those around us.

The bond that each animal has with the world—its *continuation* with it—is made possible only by the *media* that surround it. *Media* convey forms from the object to the subject, but they also make the reverse possible, allowing for the transmission of forms from subject to objects. It is thanks to media that intentional forms pass from one soul to another. And it is only thanks to the media that inanimate bodies can be influenced, acted upon, structured by living beings, and become capable of bearing traces of the existence of life and thus transforming themselves into the *world of life.* If the spirit *exists* and is not limited to being an immanent force for individuals; if it becomes mundane reality, capable of existing alongside individuals just as it exists alongside things which it shapes and rules; if it is capable of surviving both the former and the latter—then it is only because there are media. The "spirit" subsists and survives thanks only to media, which support it in life and transform it into something *sensible.* Media tear it from its purely psychic and interior existence (and therefore individual, private, undividable), rendering it infinitely dividable, giving it the specific concreteness, if not of the *thing*, then of an image of all things.

It is a mistake to define man and life *tout court* on the basis of their capacity to spiritualize the object. Life is also the ability to reify the spirit, to objectify it, to alienate it. And the first form of alienation and realization of the spirit is the image. The sensible is not only the place of abstraction of forms from their matter (consciousness in its first stage), but it is also and above all the process of reification (*Verdinglichung*), of alienation, of *transforming* the spirit and the Subjective *into sensation.* There, where sensible life exists, object and subject become poles of a two-way movement. Media transform things into spirit but allow the spirit to come closer to things, to assume a mundane existence.

The spirit of the living exists chiefly *outside of the living*, in the *media* where they have turned spirit into sensate matter. Man and all animals do not live within themselves and their bodies any more than they live spiritually outside of themselves, not yet within things, but in the *media* that host the sensible and "interior" intentions. The spirit is always ecstasy, and

it begins outside of us, even before it establishes itself as an interiority. Moreover, historians and archaeologists turn to media and certainly not to the bodies of living beings in their attempt to grasp the spirit of the living beings, which survives long after they have been buried by the past.

What lives [*vivente*], in this sense, is not only those who know how to carry the things of the world within itself, transforming the forms of objects into intentions, images of the mind, immanent and "personal" objects, but they are—above all—those capable of giving sensible existence to what lives within them. And life is, first and foremost, this sensification of the spirit, that is a medial transformation of what persists in the soul, through which one never stops outliving oneself. *Media* are none other than the perpetual nonpsychological and nonobjective resurrection (or incubation) of things and subjects. Media open up other worlds, which are nonextensive, not truly "objective" nor purely psychological, but which are perfectly contemporary to our own world.

17

MEDIAL EXISTENCE

Let us not think of the medium as a purely cognitive or noetic space. Every image is the Being of knowledge that acts outside of the subject, a sort of *objective unconscious*.

It is a form of *unconscious* in a dual sense; it does not know anything other than itself, nor does it know itself. It is not consciousness of something (*Bewusstsein*), nor is it consciousness of itself (*Selbstbewusstsein*). Nonetheless, an image remains a form of knowledge, because it represents the possibility of every knowledge of the soul; it incarnates the very being of knowledge in itself. An image is not a perception in act, nor is it the perceived object, but the form of the object as pure perceptibility and potential perception, capable of momentarily dwelling outside of the soul.

It is a form of *objective* unconscious because it does not represent a mode of subjectivity; despite defining the virtuality of every subjective perception, it is the actualization of a sensation that takes place *outside* the organ of perception.

Images have nothing to do with psychology because they exist first and foremost outside of ourselves, outside our consciousness, in the clouds, the air, on the surface of mirrors, and only later do they enter into human life. On the contrary, in the most secret and incommunicable depths of our souls the light that gives strength to each and every psychic act is something that does not have the same nature as our souls, something that is generated outside of us, but it is, nonetheless, capable of giving form and in-forming every intentional action, from will to desire, intelligence to passion. At the foundation of any psychic movement is something that has

no psychic or subjective consistency nor does it have any objective consistency.

In this intermediate realm, in this objective unconscious (or, if you will, in this strange form of apsychic consciousness), a supplementary life seems to open up for forms. It is a life placed on the other side of things, but capable the same of lingering before souls. A medium is this same supplementary world that comes after the nature of things and objects but remains anterior to every soul, to every psychism, almost as if it stopped at the threshold of history and culture after emerging from the natural realm. *Sensible life* goes beyond the nature and the identity of things because it represents the exodus of forms from their material existence, but it does not necessarily grant access to history. The medial existence (in the medium) of images is a form of survival, which does not imply death nor a proper form of truth, because it is not yet a part of the mind, nor of the consciousness of the living beings, nor of their capacity to wager on their being, or to make promises.

Yet, this supernumerary space remains the condition of possibility for every knowledge and every culture, in all forms. Psychology seems to find here the reversal that makes it true. It is not about denying that the image enters into every psychological experience, because it can exist *in anima*, within it. In penetrating, however, a foreign element is introduced that opens a nonpsychological, nonsubjective, and nonobjective space that will establish the basis for all intentional acts. The subject nourishes itself with images, and it is for this—exactly for this—that it is able to divorce from objects and from itself. Since the genesis of the sensible takes place outside of the soul, the origin of every psychological phenomenon does not have a psychological nature. At the foundation of every imaginative, cognitive, and psychological experience there is an element that has no psychic or mental nature: There is the image.

It is only by recognizing the nonpsychological origin of the image that one is able to grasp the power of the sensible on human and animal life. We live tied to the sensible, not to language. Or, if you will, our dependence on language is nothing more than the sign of how effective and influential images can be on our existence; language is nothing more than one of the infinite forms of possible sensible life. There is a form of knowledge, that is, there is sensible beyond, or better, on this side of the subject, a sensible that

circulates and exists independently from it. To know and perceive is to arrive at appropriating these minor beings, which lead a spectral existence. In becoming sensible, the real acquires the very nature of dreams, of ghosts and all the images that animate experience. The sensible—the existence of forms within media, the sensible that derives directly from the objects as well as the sensible, which is produced by subjects—is the reality of experience, but in a nonpsychological and nonobjective form.

18

INTENTIONAL PROJECTIONS

Contemporary philosophy seems obsessed with the need to understand the mind, its structure and its physiology. And in the mind it has sought the origin of everything that once belonged to the "spiritual": culture, language, customs, and even aesthetics. This unquestioned obsession is both the sign and the consequence of the reduction of the intentional dimension, which is a specific feature of sensible life, to the way of being of the mind and to the mode of existence of ideas in an immaterial spirit. Such a lessening is most liable for forgetting that what permits a form to intentionally insist upon our spirit is the same *ontological indifference* that permits it to project itself outside of the spirit and acquire an infra- or hyperpsychic consistency—a consistency that is almost hyperobjective. The intentional sphere does not coincide with the sphere of the mind even when it includes the mind; it is, rather, the state of existence of all forms when they keep themselves beyond objects and on this side of subjects, or vice versa. Recognizing a form of intentionality within the mind means to pose the existence of a form beyond the substrate which guarantees its physical reality, a form which is distinguishable from the reality of the "I," that is in some way not *purely subjective.*

In wondering about the way in which forms exist or insist upon a mirror, we have arrived at understanding it. Now it is necessary to turn toward a sphere of the sensible (of intentional forms) which is equally as broad: the realm of the images that are entirely *produced* by the living. What separates the *physics* of the sensible from its *anthropology* is not a natural difference. What distinguishes these two disciplines is the degree and intensity with

which living beings (humans most of all) *produce* and do not just receive the sensible.

The images produced by the living are forms *projected* onto the external world. Their existence does not pose structural differences with respect to the forms that the world is capable of introjecting. The study of *intentional projection*, however, allows us to better grasp the nature of what we call experience or, in a broad sense, knowledge. If the faculty of knowing can be described as the capacity to introject within oneself a mundane element, everything that can know is able not only to receive and acquire forms, but also *to project one's own knowledge outward*, to make one's own interiority exist beyond oneself. By contrast, every sensible projected outward cannot help but transmit a part of the soul to the world. It demonstrates that the psyche is essentially a heterotopy; it always lives outside of itself, in the bodies and objects that surround it, and it cannot help but contain within itself parts of the external world. The living is not simply *in the world*, no more than the world is intentionally within the living itself. In the same manner, every time one emits knowledge, one cannot help but drag a part of oneself into the world, to be alienated, to let slip one's own interiority into the external world. First and foremost, the soul is that which can go beyond itself, as image; the soul is what can become sensible. Every projective act conveys spirit into the world; it alienates it by bringing it out of itself. Any time we speak, the soul becomes world, but it is never something that adds a material entity to the collection of beings that constitute the world. The sensible transmits the psychic, but it is always a supernumerary object.

Above all, the higher activities of every animal are activities of *projecting*. And insomuch as they are forms of the projective existence of the spirit, all intentions are known as something that adds to the real, but as a supernumerary reality, a hyperreality, a form of hyperobjectivity that dwells on the surface of objects. The cinematographic image is not an object in the way that a chair, a table or an apple are. It is something that exists *on* an object (light and the screen), or better, it is a higher existence of the object. Hence, speech is the surreal of the voice. No intentional form produced by man (or by animals) exists as an object alongside another object, but rather it is always hyperobjective, surreal, to the same degree to which it is infrasubjective. This is not a simple ontological fact. If every intention is surreal, it is because in it the psychic is transmitted within objectivity and can therefore exist among objects. Every intention "hyperreifies the psychic realm."

Intention is surreal thanks to its transmissive capacity. In intention, therefore, the real achieves a superior state (because it becomes capable of hosting and transmitting the spiritual) and the psychic becomes concrete, objective spirit. These hyperobjects, these little daily surrealities can convey the *real* and the psychic into another state of being. Thanks to this third state, this world of ours remains ever magical.

19

BECOMING WHAT ONE SEES

In modernity, it was Lacan who understood most profoundly the founding role of the sensible in the constitution of the human individual. Henri Wallon had noted that a child uses the exteriorized image in the mirror in order to experience its own body as something that is unitary and controllable. For Lacan, the real issue in encountering the image of the self is not only the experience of one's own physical figure; the image is the origin of the entire personality of the individual. What has place in this "experience that sets us at odds with any philosophy directly stemming from the [Cartesian] *cogito*" is truly an "*identification*, in the full sense that analysis gives to the term: namely, the transformation that takes place in the subject when he assumes [*assume*] an image."[1] The experience of the child in front of the mirror is together the event of and the model for the genesis of the individual personality. The mirror stage is, in fact, a particular case but also the *paradigm* of the function carried out by the *imago* in the psychic life of the individual: to "establish a relation between an organism and its reality—or as they say, between the *Innenwelt* and the *Umwelt*."[2]

That an image can be capable of radical "formative effects" is biologically proven for the rest of the animal species as well.[3] Lacan cites the case of the pigeon in which the development of the gonads has as its necessary condition "that it should see another member of its species, regardless of its sex."[4] Now, in contrast to monkeys, in which interest in images is exhausted "once the image has been mastered and is found empty," in children the experience of the self-as-image "immediately rebounds . . . in a series of gestures in which he experiences in play the relation between the movements assumed in the image and the reflected environment, and [the links] between

this virtual complex and the reality it reduplicates—namely, the child's own body, and the persons and even things around him."[5] "This form situates the agency known as the ego, prior to its social determination, in a fictional direction that will forever remain irreducible for any single individual, or, rather, that will only asymptotically approach the subject's becoming, no matter how successful the dialectical syntheses by which he must resolve, as *I*, his discordance with his own reality."[6] The primary identification always occurs by means of an image. Whether this is an image of the self or of the Other has little meaning: in both cases, the "I" is a function of this originary identification and, therefore, always has an alienating function. This identification produces an identity that coincides with an alienation. This "alienating identity will mark his entire mental development with its rigid structure."[7]

Thus, it is to the sensible, to images, that man asks for a radical testimony of his own being and nature. It is the mirror that provides the individual with "an 'orthopedic' form of its totality," of his body, which is otherwise parceled out into different perceptive experiences.[8] Through "the total form of the body . . . the subject anticipates the maturation of his power in a mirage."[9] This is not just a cognitive act: The image does not provide only information about one's nature, but it is what allows such a nature to be established. "This form is more constitutive than constituted . . . but it appears to him as the contour of his stature that freezes it and in a symmetry that reverses it, in opposition to the turbulent movements which the subject feels he animates it."[10] In the end, one could say that we need an image in order to know our unity in the same way and according to the same necessity in which we need a pronoun (or a simple name) in order to refer to ourselves.

Lacan, however, seems so attentive in recognizing the clinical consequences of the gesture in which one's nature is recognized through an image, that he overlooks the strangeness and anthropological relevance of such a phenomenon. The image in the mirror, which will establish—as "Ideal I"—also "the source of secondary identifications," according to Lacan, symbolizes "the I's mental permanence, at the same time as it prefigures its alienating destination"[11]: the unity and identity carried out by the child are, in any case, alienated, imaginal fetishes of something that in reality exists on this side of the mirror and as such can never be grasped. The process of identification brings the child to a permanent noncoincidence

with itself. "The fundamental fact which analysis reveals to us . . . is that the *ego* is an imaginary function . . . not to be confused with the subject."[12] And the risk is that the subject becomes "sucked in by the image."[13]

It is not difficult to comprehend the dangers linked with this "imaginal absorption." Yet the faculty of recognizing (or misrecognizing) oneself in the sensible, of identifying with it, of exchanging oneself for an image, is something that goes much deeper but is also more profane, frequent, and quotidian than the Lacanian "mirror stage." What does it mean exactly to be able to live off our own form when this form no longer persists in us, no longer gives life and is no longer the place where we think? What does it mean to be able to live in forms in the exact moment when they have abandoned the things, the objects whose nature they defined and have not yet become psychic contents (but can do so)? The first and most immediate effect of this transcendental experience that permits the child to become a man might not be the drama of a divided and distorted consciousness; neither is it the narcissistic excess of the love for oneself which brings one to hate both the other and oneself. In this alchemy in which our form acts upon us exactly when it has stopped being ours, a faculty is at work that is often neglected by physiological treatises.

The power that permits us to identify ourselves with an image and to recognize our own nature when it is outside of us is what is often called mimetic faculty. We are subjected to that unusual "transformation that takes place in the subject when he assumes an image," that makes an "identification in the full sense analysis gives to the term" possible, every time we imitate something or somebody.[14] Lacanian anthropology (contemporary to the Debordian speculations on society of the spectacle) turns the human individual into an animal that is forced to play itself, to imitate its own image. If ancient theology considered man as the image of God who had to imitate God, for modernity (actually, for postmodernity), man must imitate himself, and maintain a privileged bond with his own image.

Philosophy has always looked upon this curious capacity of man and animal with fear and suspicion. It has always made accusations of producing a counterfeit and a less real double, of authorizing dialectical misunderstandings between the self and the other, of defining a hierarchical order among originally disparate elements, of spreading the force of the false against the rights of the true, the good, the one. In this way, one forgets that imitation is made possible, above all, by the capacity of a form to exist else-

where than the place where it originally rests. If the son can imitate the father, it is not only because he has no form and needs to assume one; it is also and above all because the form of the father is capable of transmitting itself from the father to the other. A process of achieved imitation is possible first and foremost because the form that animates the imitated is capable of existing outside of him and of informing other subjects. Imitation and mimicry are secondary effects to the power of forms to be *transmitted*. Every form, in fact, even when it seems to have an essential relationship with the subject that hosts it, is capable of multiplying itself and reproducing outside of its own subject, of transmitting itself to others, *salva veritate sui et subiecti*, that is to say, without having the subject losing it (the form) or transforming itself, and without the necessity for the form to modify itself.

Imitation is this secret life and the vehicle of all forms. The sensible metaphysically expresses this secret capacity of absolute transmissibility and of infinite appropriability of forms. The image, in fact, is not only absolutely transmissible, but it is also infinitely appropriable: The image is what permits one to appropriate something without being transformed by it and without transforming the object whose image that image is image and likeness. What sociology today calls "communication" is this *nontransformative transmission of a form*. If observed from the point of view of the medium this transmission is an appropriation. A medium is what makes this transmission possible, the flow of a form from an object (*sine diminutione objecti*) to a subject (*sine transformatione subjecti*). It opens an ultraobjective and infrapsychic space (which is however psychogenic) of absolute appropriability without things changing in any way or transforming the subjects into which they penetrate. The mimetic faculty is the faculty of immaterial appropriation (and thus of alienation) of things. It is only thanks to the sensible that one is capable of imitation, and only the sensible can be imitated. The image is the realm of imitation itself because it is the place for the extraobjective and psychogenic transmission and existence of forms.

20

LOSING ONESELF IN IMAGES

The identification that occurs in the mirror stage, Lacan claims, is possible because the child, even though he "is outdone by the chimpanzee in instrumental intelligence," can nevertheless already recognize as such his own image in a mirror.[1] The human infant is thus *less* intelligent than a chimpanzee, but in contrast to the chimpanzee, it is able to identify itself with its own image. What taxonomically separates it from this animal to which it is the closest is not an excess of reason, but the ability to recognize itself in an image, to be absorbed by the sensible, so to speak. If man can come into the world only thanks to an image, only thanks to his identification with his sensible image, then it is mostly *sensibility*—and not the capacity to think—that defines his form of life. The difference that is specific to humankind is not rationality, but rather this special relationship with the sensible.

One could quip that the chimpanzee becomes human only when it *becomes* more interested in the image than the reality that it represents. Human life, in this sense, is not marked by the event of rationality, but by

It is a delicious thing to write, to be no longer yourself but to move in an entire universe of your own making. Today, for instance, as man and woman, both lover and mistress, I rode in a forest on an autumn afternoon under the yellow leaves, and I was also the horses, the leaves, the wind, the words my people uttered, even the red sun that made them almost close their love-drowned eyes.

the power of grasping the being-image of the image. An animal becomes human when it learns to love and recognize images and lose itself in them.

The human being, who is perhaps unique among living beings who partake in sensible life, is able to make sensible and images not only the surrounding world in which he bathes at every moment but also his very own consistency. Human life does not define a genuine leap in comparison with the rest of the animals, but only a deepening of animal life; it is animal life that has brought its own possibilities to extreme consequences. Humanity is not the Other of animality or the biological, but rather absolute animal—life that is absolutely *sensible*. None of the traits that characterize human life are absent from the sensible lives of other animals; distance is always and only distance in degree, not in nature. Man has been made such by the sensible: It is life that has opened so significantly to the influence of the sensible to the point that it can establish itself as such only when it has become himself, in front of himself, nothing more than an image.

Human superiority is perhaps the power to lose oneself in the sensible, to love it to such an extent that one becomes capable of producing it. Reason is only a modification of our skin, the capacity to take the images that our body produces and free them beyond our own bodies: it is not the Other of sensibility, but a hypersensibility in which the very being of a body and a living thing is at stake.

21

DREAM

The idea that our ego has lived under the influence of a sensible image from the day we were born should come as no surprise. We experience this subtle, silent influence much more than we might think. Every night, when we believe we have interrupted any and all contact with the external world in order to embrace absolute intimacy with ourselves, our dreams do not offer us relentless contemplations of our semblance. If they do, it is only through the allegoresis of a multitude of images. Tied down to itself, abandoned to its nature alone, freed from the distractions of the world during wakefulness, in this daily existential dead end in which every living thing is forced to cease to relate with itself, the experience of the self becomes completely paradoxical. Each time we dream, our nature ceases to be defined by an anatomical body or by that spiritual ghost that we call "ego." Dreams seem to take the certainty of being able to recognize ourselves in a sum of organs or in a psyche that governs their movements and replace that with a less secure cogito. Our nature breaks up and fades away in a liturgy of voices and characters, figures and stories. All of the sudden, everything can become our form, and our ego multiplies into the living voice of all things. The opposition between the ego and the world, so evident in waking hours, here vanishes: The ego rediscovers that it must have the same limits of the world and, now, the entire world is contained and recreated by the ego. It is the sensible life that makes this chiasmus possible.

Dream, for every living being, is the supreme form of intimacy; in this case, however, intimacy coincides with the flux and fusing of the subject into the material of all things. In the very experience of the most radical proximity with one's self, our semblance, our figure seems to come undone

in the iridescence of sensible images. In the most secret depths of our soul we do not find a precise essence, a defined body, but rather the shifting spirit that is sketched over time by images. Dreaming, in fact, means first and foremost to imagine; the image is not just a simple psychic object here, but is in effect the matter or the life from which everything is made and everything is nourished. We ourselves have no other body than the one that is defined by what we imagine. Human imagination ceases to define a relationship with something external and coincides with fact, forms, and the rhythm of our existence. In dreaming, we exist only because we are capable of dreaming and only in the forms that our imagination is capable of creating. What we imagine gives us a new form, and it is the very fact that we imagine that ensures our existence. It is imagination itself which becomes body, the indivisible and nonorganic corporeality which defines our basic stratum. In dream the sensible life becomes so intense that "this very imagination seems to be a sort of life in itself, a little lower down in the scale, and having its basis in a peculiar property of nature," as Synesius wrote in the most beautiful treatise on dreams that has ever been written in the Western world.[1] Each time we dream, as Synesius holds, "we see colors, we hear sounds, we touch and grasp objects, although our corporeal organs remain inactive." We imagine, yet this imaginative life does not lie upon the sense organs, but it is as if it were an autonomous life, inferior to life awake but more ephemeral. Synesius calls this substance "fantastic spirit."[2] Dream is the very life of the spirit of the sensible, of this spirit existing in-between the objective and subjective ones, and it allows for both to become blended and indistinct within one another. This spirit, Synesius maintains, this lesser life that images permit us to live every time we dream, is a sort of generic, sensorial faculty that is more universal than all the senses because it can be affected by all things in all of their aspects. It represents "the first body of the soul" because it is what defines the first consistency of every subject: we dream, therefore we are—first and foremost— what we are capable of imagining and our limits end where our imagination arrives.[3] This fantastic spirit is also, so to speak, the first vehicle (*ochēma*) of the living; it is what brings the soul of the living toward the world of things, much prior to its anatomical body. The relation that binds us to the sensible is a true relationship of consanguinity: in dream we materially coincide with the medium of knowing, *we are made of the same matter as the images that give body and consistency to our desires and our*

fears, and we have a body which is defined by its sole capacity to be and to become what we are able to imagine. For this reason, we are unable to defend ourselves from images that affect and overwhelm us. Dream is the supreme faculty of identification, the same that is operating in front of the mirror. For the individual, it opens the place in which his own form and life depend upon images. In the very moment in which the subject is forced to withdraw into himself, the limits of the body are the limits of the imagination, and the imagination transforms any mundane object into bodily form.

22

THE INTRABODY

The images that live within us make up a type of body, a particular, minor body, what we apprehend in dream. Dream is the experience of a body that is entirely outlined by the sensible. In our waking lives, our bodies also live on sensations, and mostly when our senses are active and turned toward the external world do sensations give us *body*. It was Ortega y Gasset who first equated the experience of the body to a form of immanent dream during waking hours and then conceived intimacy as a special form of corporeality. "The body of man," he wrote in a study on the "structure of human intimacy," is the only object in the universe of which we possess a dual awareness, shaped by entirely different information. We know it from the outside, "as one knows a tree, a swan, or a star; in addition to that, everyone perceives its body from inside, it possesses a glance or an interior view."[1] Ortega calls *intrabody* (*intracuerpo*) the reality and the consistency of the body of which we are composed, as it is perceived from inside ourselves of us (*desde dentro*). Unlike the exterior body, the intrabody has no color or defined form; it is not a purely visual object. It is made up of "sensations of movement or touch, of impressions of expansions or contractions of vessels; by small perceptions of the course of blood in veins and arteries, of sensations of pain and pleasure."[2] Unlike the exterior body, whose phenomenon and appearance is separable from its existence, the intrabody completely corresponds with the range of sensations, emotions, and phenomena through which those who experience it come to know it. It is as if, alongside the *stream of consciousness* (with which William James identified the essence of the modern novel), it were necessary to postulate a *stream of bodiness* that completely coincided with the alternating of sensations in

which bodiness makes itself knowable. Because even the body, if observed by one who lives and occupies the same space as it, is never a figure, a form, but rather a series of sensorial states that are immersed in one another. And just like James's stream of consciousness, this interior body also "goes on." "The first and foremost concrete fact which everyone will affirm to belong to his inner experience is the fact that consciousness of some sort goes on. 'States of mind' succeed each other in him. If we could say in English, 'it thinks,' as we say 'it rains' or 'it blows,' we should be stating the fact most simply and with the minimum of assumption."[3]

The body also does nothing but flow, but this stream is not a byword for transience [caducità]. The stream of bodiness, rather, is the only true consistency of what we call life. Ortega conceals the cardinal principles of a new physics of bodies within a handful of apparently marginal pages. Our body is, above all, a series of perceptions in action. A body that is deprived of active perceptions, completely anesthetized, would not be our body but just one of the many sensible objects, which is possible to perceive and experience. Instead, our body is the body that defines itself as a set of actual perceptions. "Others" are the bodies that generate these perceptions, bodies that make themselves sensible: the sensible bodies. In the realm of experience or perception, the line that divides subject from object is much less clear-cut than one imagines. Both are aspects of perceptive actuality. Intimacy is the coincidence of existence and perceptibility, which defines the world as an area in which everything is distinguished according to reciprocal gradients of intensity of perception and perceptibility. Every intrabody (the Leib of phenomenology) is distinguished from "other" bodies (body mass or body extension), inasmuch as it is the paradoxical place in which every sensible is sensation in action, and every ongoing sensation is, in turn, a sensible. The naïveté of physics is to think of some bodies absolved from all active perception without realizing that the extension, and the atoms that bump and collide with each other, which physics imagines matters to be made of, are nothing more than "objectified tactile perceptions" that get passed for independent realities. There are no absolute bodies: in the intracorporeal stream (in the living body), everything takes form as perception and through perception, but neither before nor after perception. The living dwells in what it perceives and lives only thanks to what it perceives. What we call dream is the most incandescent form of this stream. But it is also the living matter on which the experience of our body takes shape

during waking hours, which stands in relation to the dream as the dark rock does to the burning lava that generated it. Everyone carries his intrabody in himself, in silent but inevitable company. It is the invariable character who intervenes at every scene of our life, without drawing the attention on him. And it is within the intrabody that the deepest roots of our character are found, in wakefulness or in sleep. One should never deduce the nature of the living from its figure that an observer perceives from the external. From the point of view of the one who lives, the body never exists as a simple object that takes up space, but it breaks down into an uninterrupted series of imaginations and perceptions, in a corporeal current made of light or shadow, of dull or lively sensations. This is the intrabody; this is the stream of sensible matter in which we exist. In the intrabody, everything exists as image; it is a stream in which things—and our very own nature—become knowable as a difference of degrees and forms of an internal sensorial perception, which has no need of organs. The *stream of bodiness* is a perception that is outside of the organ; or better, in this stream every organ is a form of archiperception, a river that runs together with the rest.

The intrabody is the riverbed in which everything must be able to construct itself in order to have a part in our life. Movement and action also exist only in the medium of this stream; not only are we always forced to imagine all of our voluntary movements, but every movement, voluntary or involuntary, can also exist above all as sensation, conscious or unconscious perception, and never as simple fact or mechanism. One could push Ortega's intuition further and claim that the body is everything that makes itself immediately knowable from the inside (*desde dentro*); the very thing that it cannot give itself if not in the actuality of sensation. To make bodies a mere place of abstract extension and spatiality means continuing to observe them from an external point of view. The *intrabody* is the per se of every living being, the sensible life within us, our life *in* the sensible.

23

BEING CONSTANTLY ELSEWHERE

In dream, as well as in the waking hours, the sensible defines a part of our body, and vice versa; our body is the making present [*attualità*] of a certain sensible. A new anatomy should cease to see our bodies as only a deposit of forms, the substrate (*hypokeimenon*) of what we do or achieve, and this because action itself and all of the operations in which our existence is broken down are *body* and are not formed on a body that precedes them in being, as well as in form. The sensible life prolongs our existence inside and outside of us, as an *ultra-anatomical* body. "Man must be divided in two bodies, the body that we see and the body that we do not," Paracelsus suggested in a passage dedicated to the nature of imagination.[1] "I shall make an example: I see a house in front of me. Someone who is in front of me could say: 'I see what you use in order to see the house,' that is, my eyes. In reality he only sees one half, that is the instrument, but not truly the sight in action (*das Gesicht*), which is the other half. The body is a part but what it exists in and operates within is the other half. The same can be said of when I hear something, my ears are a part and what I am hearing (*das Gehört*) is the other part; when I speak, language is a part and the voice is the other."[2]

The sensible and contact with the sensible make man live in an ulterior body, in which we are no longer separable from everything we experience, or from the *fact* of seeing or feeling. This *ulterior body* is the most concrete reality of life, the alive flesh of experience; it is not the substrate but the act and very matter of personal experiences. Experience, everything we live, and the very *fact* of living, are not only accidents or the effects [*affezioni*] of a *res extensa* in which there is neither sensation nor affect, but rather the other side of the body, its less visible consistency. Seeing and hearing in

the moment, like every vital operation carried out by the living, is *body*. It is as if experience itself were a body, a sensible body whose place is elsewhere with respect to us in the same manner in which objects are elsewhere. *If man "sensifies" the spirit, the sensible life, images, they give body to our spirit. This body, however, is different from our organic one.* We consist not only in what permits us to perceive, but also in what we perceive, in perception itself. Like dreams during the night, our experience in our daily life builds our second body.

If the sensible gives us body, this is because it is not merely an intentional content of consciousness. The image is not merely a cognitive fact: It is a state, the mode of existing of forms. Forms become images—hence, they become sensible, making themselves knowable—when they are found in the state of absolute appropriability and transferability. The sensible, the image, makes things and forms exist, in the particular mode of absolute transmissibility and infinite appropriability. A thing inasmuch as it is a sensible image is not the same thing to the degree that it can be elsewhere with respect to its proper place (*esse extraneum*) without severing the link with its original place and without its persistence outside of itself provoking any sort of change. It is the medium that allows forms to exist in this manner. Those forms are alienated with respect to their own matter, but it is this fact that makes them infinitely appropriable. This coincidence of the image's appropriability and alienability is what defines the statute of our experience.

It is for this very reason that our sensible life, *experience*, is not found only in our biological bodies. A random conversation with a friend does not exist solely within us. It holds equal rank within internal senses (where it joins with the sensible therein stored in order to provide a place for much vaster complexes), but it is also is in the air (and this medial existence of conversation permits the two subjects involved to have the *same* experience, as well as permits others to take part) or in a mirror in front of which the two subjects might have found themselves. Experience, the sensible life, is always able to be elsewhere from the place in which it was produced. In fact, it has always been in another place, or better, it is *the being elsewhere of any form*. Every experience is actively secreted by subjects, but experience does not live more in us than it does outside of us. Now I am in front of this page: Where does my experience of the word take place? Where does my experience as a man who is now writing this text exist? Where is what I think located? In me, in my hands that are writing, in this paper? If language

is a transmitter, this is because experience (the sensible inasmuch as it is infinitely appropriable from whatever object, *salva veritate existentiaque rerum*) is capable of existing and living elsewhere in contrast to the object that it resembles and in contrast to the subject for whom it opens the world and its truth. The image is the capacity to live outside of one's own matter and with the same intensity, the same legitimacy with which it persists in the memory and in perceiving organs. For this, the capacity to make experience completely coincides with the ability to free oneself from experience, to make it exist outside of oneself, and, in a certain sense, to lose it at any moment. The tiresome complaint so frequently made nowadays concerning the "loss of experience" is a theologian's prejudice. The sensible life is capable of making images live outside of themselves, and to free themselves in some manner, to lose them without hesitation. As we are capable of experience, we have always been living elsewhere with respect to our biological body. Only a stone lives solely within itself, for the very reason that it is incapable of experience, hence of having a relationship with what surrounds it in the form of mere image, sensible. Experience gives a purely mundane body to the living. It is what gives concreteness to the living; it is what links the living to the world, to *this* world. It links it to the world as it is here and now, but also to a world that could be elsewhere and in another time. We do nothing but appropriate and free ourselves from images.

24

SEEDS

The sensible defines the infinitely appropriable. An image is what permits the subject to appropriate a form without transforming its nature or the nature of the object it resembles. Every image opens a space of absolute appropriability for things *salva existentia veritateque rerum*, without those things changing in any way. Language—one of the highest forms of the existence of the sensible—is the most malleable faculty of the immaterial acquisition of things (and of their alienation), a kind of transcendental medium. Every medium, in fact, is not only what it receives (that which appropriates something according to the form without transforming itself or the object from which it receives the form); but in bringing things into existence as images, it is also a transmitter. It is thanks to the medial space that every living being can appropriate images. Every medium transforms the contiguous world into an ulterior medial space capable of acquiring and transmitting the sensible form that is shaped in it.

Every image is *the authentic being of transmission*. It is the place in which reception coincides with infinite transmissibility, and where transmissibility rests on a reception that has already occurred. Only within the image can life be passed down, and only through images can humanity transmit the most dangerous truths to itself. Every true learning, then, will be nothing more than a fragment of a collective dream or an unknowable form of interpretation of dreams [*oneirocritica*]; only in dream can the living being succeed in transmitting the most secret truths to itself, and every truth that is transmitted is a dream or interpretation of dreams. Dream is the quintessential place of the *passing down* of all truths (from those divine to those

Semina sunt vincula utriusque naturae, visibilia invisibilibus coniungentia; in quibus motuum leges, temporum praedestinationes, generationum et transplantationum lithurgiae et universae mundanae anatomiae dispensations continentur, tanquam in vitalibus potentiis incomprehensibili sapientia decoratis; quorum ministerio agentium impressiones a patientibus admittuntur vel repelluntur, summa infimis coniunguntur, et totius naturae sympathia custoditur, ex quibus sapores, odores, colores et qualitates vitales omnes, quantitates numeri, conformationes et signaturae coeterae, in mechanico generationum et transmutationum processu procedunt.

human) and of communication not only of the living with the dead but also of the subject with itself. It is the very being of tradition.

Within the cultural sphere, dream coincides with what in nature is called the seed. The image, we have said, is a form that is transferable and absolutely appropriable, and imagining always signifies transmitting something. Herein lies the reason that reproduction must occur under the appearance of the image (*sub specie imaginis*); it is only in the place in which life becomes image that life can make itself capable of being passed down. Reproduction is corporeal imagination. A seed is the threshold in which images transmit the living being's life as a whole, not only a particular mode of such a life or a fragment of its world. The seed is an image that can live and give life. It is a life that has no other nature than that of an image. Within the seed a body is nothing more than pure image, and the image has no other nature than that of being the *form* of the body. All reflections on the seed made in the Western world, from the theory of productive forms (*logoi spermatikoi*) of early antiquity until modern genetics, is a reflection on the ways and the forms of this strange coincidence. Indeed, what does it mean to reproduce oneself? Reproduction is the constitution of an individual *through* an image of those who have generated him. It is not a simple multiplication, but rather a multiplication that happens spontaneously through an image, or better, through a body that consists solely in the being-image, in the *species* of the individual. Reproduction is the very fertility of the image.

What we today call imagination is perhaps nothing more than a diminutive form and a derivative of this transcendental faculty of the image that we see in action in all procreation and in the very fact of the living. Every seed is a dream without eyes, the dream of matter, exactly as a dream is a psychic seed, the way in which the soul reproduces outside itself.

25

INFLUENCES

As every exterior image has psychogenic consequences for those who receive it, so too does every image that we emit produce effects. If we emit images, if we strive to sensify the spirit, to produce the sensible out of it, it is because images are not merely cognitive realities. Above everything else, they act. Odors, tastes, sounds: Everything of the sensible has effects and exhibits an efficacy that is difficult to define because it is inferior in rank to the causality that the real exercises on the real. We continuously experience such causality in the realm of language, our principal channel of production of the sensible. Whenever we speak, we presuppose that the sensible that we produce has effects. It can astonish or spark a reaction, offend or persuade, soothe a worried soul or raise a smile. Every time we speak, we confide in the efficacy of the word, which must in some way influence whoever hears it, even if that means in the worst of cases to be the simple awakening of knowledge in one's consciousness. Language must always produce effects and have influence. Rhetoric (which is no more than the science of the effects of language) is thus the highest science of influences.

The alienation of the sensible always depends of the power of images. The true effect of every image corresponds with its reproduction, its multiplication in a different matter; its effect has no other form but its own. The effects created by an image are, in fact, "in its own image." This isomorphic quality between cause and effect is the very characteristic of that special form of causality that we call influence. A cause always produces something different from itself: The image does not produce effects that are different from it, but rather it reproduces itself. Its mode of causality coincides with its own multiplication. An image always and only arises from another

Alia est enim divisio causae et alia divisio fluentis principii. Non enim fluit nisi id quod unius formae est in fluente et in eo a quo fit fluxus. Sicut rivus eiusdem formae est cum fonte, a quo fluit, et aqua in utroque eiusdem est speciei et formae. Quod non semper est in causato et causa. Est enim quaedam causa equivoce causa. Similiter non idem est fluere quod univoce causare. Causa enim et causatum univoca in alio causant aliquando. A fonte autem a quo fit fluxus non fluit nisi forma simplex absque eo quod aliquid transmutet in subiecto per motum alterationis vel aliquem alium. Sicut dicimus formam artis ab arte simplici fluere quae eiusdem rationis est in spiritu qui vehiculum suum est, quando fluit in manus et organa artifici set quando accipitur in ipsa arte ut in origine sua. Si enim aliquid transmutat materiam in quam influit forma defluens, hoc tamen nihil est de essentia principii, a quo fit defluxus. . . . Nec est idem quam principiare. . . . Omne principium aliquid rei est, cuius est principium. Et hoc sonat ipsum nomen. . . . Id autem quod fons talis fluxus est, de quo hic loquimur, non semper aliquid rei est, quia primus fons nulli commiscibilis est, nec pars esse potest alicuius rei quam constituit.

image; the first effect of an image is always another image. Indeed, an image is efficacious only because it is the existence of a form capable of existing outside its proper subject, that is, capable of being appropriated and alienated. Every image is a form that is capable of flowing from one subject to another. And if the effect of every image is its reproduction, the efficacy of images corresponds with their own nature, with the fact of being able to generate themselves beyond where they have been. The life of the sensible is the flow. It is for this exact reason that the relationship that we hold with images—a relationship of external and internal efficacy—is always a relation of influence. Every influence is a question of flow. Influence, therefore, is the transmission of a same form, which exists thanks to this in another subject [in *alio subiecto*].

Seen from the point of view of those who are subjected to influence or receive the flow *and ex parte objecti* this process takes on the ordinary name of imitation. Indeed, what does it mean that the image always and only produces effects that are perfectly isomorphic? It means that the image gives rise to imitation; it creates resemblances. If the efficacy of the

image coincides with its multiplication, with its reproduction in foreign subjects, then in its reproduction the image does not constitute a new subject but is the object of spontaneous imitation. And this occurs only according to form, not according to matter.

Influence is the efficacy of what can release its own form, give it [*donarlo*] without losing it. It is the existence of a form that can alienate itself from its subject to reside elsewhere; that is, it can be appropriated by others. An imitator is whoever can allow oneself to appropriate a foreign form without losing or changing one's own form, one's true nature, without ceasing to be materially distinct from those who one is imitating. Being subjected to influence does not mean transforming oneself or changing identity. We can experience influence without even realizing it, in the perfect conviction that we are following what is most personal within us. Being influenced means having received a form that comes from the outside without being altered by it. Imitation and influence are the very life of the sensible. Where there is an image, so, too, is there influence.

ON THE SURFACE OF THE SKIN

The sensible life is not something that the senses alone allow us to experience. The senses do not define its conditions of possibility. It begins earlier because of the apparently banal yet decisive fact that every living being *appears* to other living beings. The contact among living beings always occurs *sub specie imagines*, in the appearance of the image. Every living being is, first and foremost, an appearance, a form, an image, a species. And appearance itself is not an accident; it is a faculty. It was Adolf Portmann who taught us to understand the appearance and countenance proper to living beings as the exercise of a specific power, and not merely a secondary and accidental trait of their mode of being. The baroque livery that a peacock brings with it wherever it goes, the nervous, chromatic minuet drawn by the wings of a butterfly in flight, the enchanted arabesques that transform the plumage of the bird of paradise into a costume that extends about their entire body: These are not mere results of a random evolutionary dynamic. "We know of many designs whose formal characteristics do not lead directly to the possibility of natural selection."[1] In general, the form in which every animal appears "is something more general than merely functional adaptation." Rather than being the extreme deposit for petty trickery of the will to reproduce, we must recognize the expression of a true poetics (a biopoetics, in the words of Portmann) within the features of all animal species: a poetics in which all living things are busy making and unmaking their own nature. "Thus not only are the pure purposes of preservation realized in the flower and its forms; beyond these the shape [plasma] that is characteristic of the species manifests *its own particular mode of being*." Living beings "are not only living machines whose activity

consists of metabolizing, in the function of which they live." Above all, they are beings that manifest themselves in their own particularity without this self-presentation being in relation to the sense organs as receptors. This faculty, which Portmann calls self-presentation, is the most fundamental feature of any living species. "Every form that belongs to the realm of the visible is therefore a specific mode of presenting itself." Living beings could almost be defined as the entities that constitute themselves in the medium of this faculty. "The modalities for self-presentation are the essential element of the animal's mode of being." Everything in an animal seems to be the expression of this faculty, thanks to which one's own nature is determined by appearances: the sing-song rhythm with which the grasshopper communicates its amorous willingness, the freckled drumming of *Digitalis purpurea*, the perfume emitted by the light beating of wings. "Above all, the visible appearance of an animal is to be understood more broadly than the self-presentation of the individual animal. Not only are the proper optical-acoustic and olfactory features of the individual animal, which resides in a state of repose, part of the self-presentation, but so too are its movements, its forms of expression, and all of its manifestations in space and time. Even a phenomenon, say, of bird migration, ought to be considered an element of this higher vital trait." Living means to carve out our appearance, and only in our appearance is our nature decided; all of our identifying traits are forms of appearance, and the first content of our nature (and its first place of realization) is our appearance, our species more than anything. It is no accident that the technical term for designing the biological identity of every individual names none other than its sensible appearance, its species. Within the definition of our appearance, there is always our nature in place, and every time we modify our nature we modify our appearance, our very species. Literally, we change skins. Everything that biology enumerates as form or nature should be considered as an expression of this faculty. The animal is the entity in which nature is entirely at stake in its appearance.

Living means appearing, because everything that lives has a skin and lives upon that surface. Above all, it is the skin that allows for the constitution of the animal as an entity that lives solely in and from its own appearance. "The scales of the wings of butterflies and the chitinous armor of the beetles show metallic colorations, golden or purple chromatic structures, whose meaning far exceeds the demands of environmental adaptation. The

feathers, hair and skin of vertebrates with their nerves and muscles are, in terms of form and color, visual apparatuses marvelously specialized so as to be at the service of the eye that sees them." Everything happens at the moment in which the surface of the animal loses its transparency and becomes opaque, and the skin itself becomes visible and the medium in which the living thing can make itself visibility in action. In this moment, the animal begins to live of its own appearance, finding within its appearance its very breath. "The fact that the surface defining the animal becomes opaque determines a whole world of new relational possibilities." The skin ceases to constitute a simple boundary of protection, transforming itself into a special organ "which serves in the first instance and in different ways to construct the appearance." The limits of the organism, the place in which the organism differentiates itself from the rest, as well as acquiring contact with the rest, "becomes an organ," a place of existence and of life, an organ of ornament in which "the outermost *speaks* of the innermost"; interiority is a fable or myth that our form never ceases to tell. Thanks to the skin, the entire body becomes simply *organe à être vu*, a metaphysical lung that breathes in light and images in order to appropriate them, transform them, giving them a modality. *Alive is whatever being has a skin, because only those who are capable of relating with their own appearance—to their own species—as a faculty and not as a simple property are alive. The form of a living being (its eidos, its nature) is its appearance, and appearance (that is, its species) in every living thing is a faculty, a power, an organ.*

Our nature, then, has no more consistency than that of an affectation; identity, the genus and species of an individual are decided by the care that each living being puts in giving form to its own appearance. If, in fact, specific characters—those which define the belonging of an individual to a determinate class—materialize only in the exercise of the faculty of appearance; if every nature must make itself ornament in order to have consistence, and it has no other means of expression than the power of ornament, then the measure of every identity will be as aesthetic as it is biological. Portmann uses the generic term *fanera* for any expression of this faculty. *Fanera* is the secret capacity of every animal to transform its nature into fashion, to overturn its own substance into mannerism. In the smallest of marks impressed upon the face, in the grace of the movement with which we walk, in the irreproducible accent which defines our speech, it is our very nature which is in play—not only accidental traits. In

exercising this faculty that is so neglected by biologists, a living being does not put into action only secondary traits but the very belonging to one class or another. Portmann transforms all nature into this comedy, into the frivolous theater in which all species are nothing more than the fashions that living things knew to choose in order to come into light. Just as every individual is inseparable from the style which defines his gait, his demeanor, his way of existing, so also is every living being inseparable from the fashion that defines its belonging to one species or another. Perhaps we do not call life that which can relate to itself only in the form of a dress, a style, a fashion; the living being is what has no substance but can access its substance only through a dress, a fashion. Only those who do not have a being but, rather, ways of being, are alive. Perhaps it would be necessary to reformulate the much-celebrated Aristotelian *logion* for which *vita viventibus est esse*. Life exists for every living being only in the form of a fashion, never in the form of substance. Life is what does not have a substance but rather fashion; the individual is a fashion of the genus, and the life of every species is the rhythm of a changeable fashion that is visible only to the eyes of the gods.

27

METAPHYSICS OF CLOTHING

Commerce with the sensible is not just passive, nor does it have merely cognitive functions for the human animal. *Man is the animal that uses the sensible not only to know and be known.* The experience of the mirror is the first and most immediate demonstration of this fact. Only by appropriating an external image does a child become a human subject; images have the power to generate and give form to the unconscious psychic space. This power goes well beyond simple gnoseological functions. In the commerce with the sensible, there is always something in play that is more than just the production of knowledge. By contrast, the relationship with the sensible does not take place solely in perception. In a word, sensible life is not reducible to the perceptive power and its five senses. Sensible is life made possible by images, the life that images make possible in all its modes and in all forms. Every form of acquisition, possession, reelaboration, and diffusion of the sensible is a part of the same sphere and must be considered as an expression of this life. In much the same manner, images (the sensible) are capable of living in us according to modes of existence that are different from the one images take up in consciousness and perception. This happens because we live from the sensible mostly not to fulfill cognitive ends.

We experience this daily; fundamentally, a dream is a kind of autonomous life of the sensible within us. Man does nothing if not acquire and give sensible back to the world, and not only in the perceptive sphere. Dreaming, drawing, and even dressing, putting on makeup or speaking: As

The entirety of anthropology is concealed within clothing.

we have seen, these are all activities that are forms of our sensible life, but they are always more than mere perception. For the very reason that we can draw, that is, make free a sensible—that is, make it exist as such in a medium—mankind can always acquire this sensible and incorporate it without perceiving it. In comparison with the rest of the world, man himself is a medium that acquires and gives the sensible back to the world; he gives back himself first, his own image, his own appearance. All of this is particularly evident in fashion—and in its most extreme case—in masks; what is dressing oneself up if not physically acquiring and incorporating a sensible that is external? Perhaps it is only in reflecting upon what truly occurs whenever we dress ourselves that we are able to finally comprehend what the nature and reality of our relationship with images is: our daily, hand-to-hand commerce with the sensible. According to the renowned biblical legend, the attire made by Adam and Eve was the first object produced by humanity. Defining the sensible life that is proper to living beings through fashion would also mean understanding more concretely the way in which the sensible life is the first place of objectification of the human spirit.

What does it mean to have the possibility to dress oneself, that is to live in clothing? The existence of dress, its reality, its forms are surely fixed and empirically definable. Every article of clothing satisfies both precise biological necessities, such as protection from the cold or from specific atmospheric agents, as well as respond to cultural urgencies. It can provide identity, mark social and spiritual differences from other people, and raise an individual symbolically above or below all other individuals. Its effects

In the cultural history of humanity, clothing is without a doubt of paramount importance. Fashion and dress define the origins of every culture, and according to even biblical tradition, the creation of clothing was the first need of man. Not only did he for the first time have to turn to a made object to satisfy this need, but it also meant the first change in his life: with dress so, too, was fashion born. . . . With the clothing of Adam and Eve, the art of fashion had already gone through two important states: It differentiated between seasons (summer and winter collections) and between genders (men's and women's attire).

truly are infinite. However, the metaphysical statute of attire, the transcendental conditions of its existence, its very possibility, remain quite unclear. What is the metaphysical correspondence to the fact that man can dress himself? What does he express in clothing? What is the nature of dress? Neither animals nor gods have dress. Clothing is a feature that is truly human. A sound, biological definition of humanity would be to describe man as the living being capable of clothing itself (*zoōn himatia echon*). Man is the animal that has learned to dress himself.

In order to understand what dress truly is, it is necessary to turn to its most extreme, ornamental, and decorative forms: makeup, jewelry, necklaces, cosmetics, and the forms and colors that we give to our hair. Here, in fact, dress no longer responds to any presumed natural need for defense or protection. Here it exists as a natural fact, without responding to any ends but those of one's own shameless existence. There is truly a paradox in cosmetics that only Georg Simmel seems to have noted. Ornament and every form of cosmetics specify a kind of "human radioactivity."[1] They produce "a larger or smaller sphere of significance." "The radiations of adornment, the sensuous attention it provokes, supply the personality with such an enlargement or intensification of its sphere: the personality, so to speak, *is* more when it is adorned."[2] Yet if it is true that the "adornment intensifies or enlarges the impression of the personality by operating as a sort of radiation from it," such an "accentuation of the personality, however, is achieved by means of an impersonal trait."[3] In every cosmetic act, while attempting to underline our individuality, we take ourselves wrongly to be feature of the world (a handful of colored powder, a stone, some particular metal, a well-cut piece of fabric) that has nothing to do with us (nor from the point of view of Being, generation, form, or material).

In order to be absolutely recognizable, we mix with [*ci confondiamo*] something that does not belong to us. And this is the real paradox of cosmetics and of every dress: the fact that a portion of the world that is completely foreign gets closer to us and our ego than our very own body. An extrinsic portion of our body, which is made solely of images, is able to convey and express our soul, its psychology, its character, more than our anatomical body ever could. With makeup and ornament, a portion of the world expresses ourselves better than our own bodies ever could. In every cosmetic, the individual dwells in *things* in the precise degree in which

things become the individual's form. In dress, the individual becomes able to dwell in the world for a moment, to establish him or herself in things: Things become a vehicle for subjectivity.

There is a curious shifting in cosmetics for which our soul becomes almost totemically univocal with certain objects, substances, forms, and colors that are, in fact, completely equivocal in our regard. In much the same way, by dressing up we identify ourselves with a feature of the world; we make it a bearer of our own spirit, expecting that our own personality will emanate from this feature. It is as if dress—which once it is taken up seems to transform suddenly from an inanimate body into an animate body—demonstrates that life passes through foreign and inanimate bodies, can dwell in objects, costumes, and habits.

What we call fetishism is only the most evident aspect of this capacity of life to be transmitted not only by the mere living. Simmel defined ornament as "an inextricable mixture of physiological and psychic elements."[4] Now, this inextricable intertwining between the physical and the psychic, between body and soul, spiritual and empirical seems to highlight mannerism as the fundamental structure of every subjectivity. One normally defines the spiritual movement specific to the ego as the capacity to recognize oneself in something foreign that through this movement becomes something proper to the self. It is the same physiology at work in every form of ornament and, deep down, in every dress. If dress reveals the originary physiology of the Ego, it also unmasks the most tenacious of superstitions concerning the myth of subjectivity; in dress, we discover just how illusory it is to imagine the existence of a self separated from the world that would be bound to the self only arbitrarily, just as a world that can exist without a subject to inhabit it. The nature of the ego is that of a whim whose object is always the world. On the contrary, the world is always and only *kosmos*, ornament, the makeup of an ego (either collective or individual). Only those who can make up and disguise themselves can truly say "I."

28

FASHION

Fashion is often interpreted so as to understand better the form of the special relationship with temporality or is delved into with the aim of grasping the relationship that binds the individual to the society and its rules. The meaning, however, of the very *fact* of having clothes remains to be understood; what does it mean, in any case, to have to don clothing? Why must we *always* define our body through this capacity? What is the life that fashion introduces us to? What do we experience in the clothes that we wear? A piece of clothing is, first and foremost, a body. In any form of attire we experience a body that does not correspond with our anatomical one. Getting dressed always means to complete our body, to add a further layer to our anatomical body. This layer is made of the most disparate of objects and materials, and the only aim is to make ourselves stand out.

This secondary body of ours that takes form in dressing (a body that is always held up by our anatomical body) is made not of flesh but of mere *appearance*. And it is always in the medium of this nonanatomical body that our anatomical body appears, makes itself seen and reveals itself. If, as Portmann claimed, every animal possesses a supreme faculty in which it produces itself as an image, that is, as a *fanera*, then dress is the place in which this faculty acts on behalf of human beings. It does not act directly upon our own anatomical body or the media that surround it, but rather it incorporates extraneous fragments of the world, foreign bodies through which our self is made to appear. The corporeality that dress embodies exists primarily as an empty space, as something that *must be occupied* by a certain portion of the world, something in *which everything* can act as our *fanera*: our skin appendage. Understood as a faculty, as the power that

allows us have (or need) clothing, it is the technique that permits the transformation of any object into skin. A dress [*la veste*] is a body transformed into skin; *it is the faculty of transforming the absolute improper into the absolute proper, and vice versa to transfer (alienate) the proper (what is most intimate to us) into what is absolutely foreign*. Nudity, in fact, is not the other face of this faculty that allows us to alienate our skin as an external object or to turn any mundane or foreign object into our skin. The possibility of nudity for man coincides with this faculty of alienating the proper in the improper and with the power of transforming the improper in something proper. Thanks to nudity, we are condemned to changing skin, clothing, attire, and to living of habits and not of nature: No attire can ever transform itself in nature, because we can never completely appropriate any clothing. Dress and nudity are not opposite terms; to dress oneself is the ability to be nude outside of one's self, through a third body. Nudity, by contrast, is the faculty of alienating from oneself what makes up one's body, of recognizing ourselves beyond our appearances. Neither of the two explains human nature better than the other: Only an embryo is forever dressed, and only a corpse is irreparably naked. Human life is the tension between clothing and nakedness. If clothing is a foreign body that has become one's own, nakedness is the absolute transparency of this second, nonanatomical body, its condition of possibility.

In man one finds as separate that which in the animal is given as joined: In the animal or in the plant, dress is incorporated and united with the body (insomuch as the clothing of man is made of exactly the most superficial strata of plants and animals—leather and leaves). Human attire is a cut in the interior of the body, not between the body and its external, but rather between an anatomical body and a prosthetic and purely virtual one. Clothing and the anatomical body are two realities of the same body. Clothing is only a portion of the body that is separated according to Being and appearance. What is expressed in the reality of clothing seems, therefore, to be a kind of *immanent* articulation of the human body. It is as if the body of every man were divided in two: There is an anatomical portion and a prosthetic, purely supernumerary one. This supernumerary one consists of any portion of the world or of an object and it makes itself knowable and exists as an empty place that must be occupied by something. Clothing is the index of a corporeal insuppressible duplicity. The human body is never entirely given; rather, it is incomplete. Its most superficial state is purely

virtual. It must be constructed out of the most disparate worldly objects. In reality, what is made knowable in clothing is the impossibility of reducing human corporeality to a mere anatomical fact. Phenomenologically speaking, the human body is always given as articulated in two: as an anatomical body and as a further body incarnated by clothing. One could say that every human body is made up of the set of the existing organs and by an additional faculty of incorporation of foreign bodies (the faculty of clothing) that allows for the recognition as one's own (or as the extreme limits as one's own body) a series of foreign bodies that do not participate in our own nature. Mankind always exceeds his anatomical body—he or she is clothed. Mankind is also defective: He or she is nude. Either a supplementary body is lacking or it is possessed.

Fashion is a process of imaginal identification performed through nonpsychological means. It is not only the interiorization of the image in the mirror that allows us to become an "I," but any kind of taking on of an image that is capable of making us appear in a certain way. What takes place in fashion is the exact inverse of what occurs in consciousness. In the latter, the world is made image in front of us and within us. In fashion, it is we who become image in front of the world and outside of ourselves. *In fashion, in other words, it is we who are transformed into a medium; we become the medium of existence of ourselves as image.* For this reason, anything that has consciousness must have fashion, and only who has fashion can be conscious of one's self. Fashion and consciousness are two faces of the same phenomenon: Consciousness is first and foremost the evidence of a noncoincidence between the subject as capable of thought and the way in which the subject appears and makes itself knowable to itself. Similarly, fashion is the organ that forces a person to appear different from how he or she is, and that hinders a person from asserting himself or herself in just one way. By virtue of fashion, the human being must constantly appear in the *medium* of another sensible image of himself or herself.

29

MAKING THE WORLD OUR SKIN

If, as we have seen, skin is an organ of appearance, then skin and imagination (or skin and language) are tied together in man by an extremely deep bond. Just as dress expressed the faculty of transforming into one's own body—in skin—a foreign, mundane object, so then is language the faculty which makes our appearance (in this case our auditory appearance, our phonic skin) a piece of the world. Speaking means making our skin exist outside of ourselves; it means alienating our skin. Every activity of intentional projection of the sensible life is like the production of a kind of "mobile skin," capable of living beyond ourselves. In this sense, human language has the same relation to clothing that animals' call has to their coat or fur. Language is a call made capable of any form of sound, just as dress is nothing more than a coat capable of identifying itself with all bodies of the world. *Man is the animal that is capable of transforming all things in his coat [mantello], that is, in his skin.* And, vice versa, man is the animal capable of transforming his skin into a worldly object: language. In contrast to what a renowned Heideggerian *logion* claims, man does not make "experience of the Open": His being and his body itself are open. *Between him and his skin there is the world.* Everything can become its skin and its skin, the organ of its appearance, can become a thing. Since human life is sensible life in its most extreme form, it is capable of reaching where the world arrives. The human brain coincides with the world. The world is our very own intellect; we have no other reason than the world of which we are a part. The world is our skin. Dress and makeup show that, in reality, man lives always and constantly outside of his anatomical body as well. They also show that the subject, the soul, or the individual is more immediately con-

veyed by a portion of the world that occupies the space of dress (or of ornament) than by the anatomical body. Our being-in-the-world is designed, opened by our nudity and hence by the capacity to take on a portion of the world as clothing: a second body, a second nature, that is closer to our soul than our own anatomical body is. *Thanks to our "nudity," we live outside of ourselves more than we live within our body; we are* conveyed [*veicolati*] *by an extrinsic and completely separable portion of the world more than we are by our anatomical body.* The mask essentially is this paradox; the paradox of mediality, for which our body is medium; a vehicle that transforms us into image and forces us to appropriate images in order to give form to our body.

Our being-in-the-world does not, in fact, have the feature of thrownness, nor does it have a feature of simple in-being. Man has a relationship with the world that is similar to the relationship that every animal has with its own skin. The world never ceases to become our second skin. Our first modality of being-in-the-world is realized in clothing: The fact that we are thrown into the world means that we can dress in it. And we are our clothes as we are in the hotter, immediate, and more welcoming portion of the world, the portion of the world that is most difficult to separate from our body, so near as to define its form, its appearance, and its *species*. If our primary and most immediate relation with the world is the one defined by clothing; if clothing is the paradigm for our being-in-the-world, the world, then, is first and foremost a vehicle and a medium of expression and not just *space* or *place*. Every piece of clothing has something uterine. Attire is something in which we reshape the stage of the egg. And it is our first world, our first *home*. There is a metaphysical link that is yet to be studied between dress and home. Our clothing is our first world—our *oikos*—and the home is an extension of clothing.

30

THE BODY OF CLOTHING

Clothing does not stand opposite the body. It is merely a second or minor body, in the same way that the organic body, according to ancient Platonic theology, is the first clothing of the soul. Clothing, however, has different features vis-à-vis the anatomical elements of the body. Clothing is a body that lives solely as image, and it transforms our anatomical body into a medium. The anatomical body and clothing, therefore, are two poles of the same reality: the individual, who can never be defined solely through one of these two elements. Thanks to the former, man is capable of life, and thanks to the latter, life appears. The former is made of flesh, while the latter serves only to transform the subject into image. One is something that is born and dies; the other has a temporality that is completely indifferent to birth and death. If biology has long strived to understand the conditions of existence of this first, anatomical body, yet we still lack a phenomenological description of the form of life that guarantees us our second body. How do we live in the body of clothing? Or better, in what way does this secondary body permit us to exist? What is the specific being-in-the-world that becomes possible within it; what is the life that it opens for us?

Clothing, our second body, can materialize in anything; it is defined neither by a specific nature nor by a specific matter. It does not need to let those who wear it be, but gives them the possibility to appear as something that they are not. It is a body in which we are nothing other than images, purely sensible beings. Dress is the organ that suddenly transforms all of our nature into *species*, into a sensible form. In dress we live only as ephemeral appearance. And if in animals the *fanera*, the skin appendage (the in-

dividual as mere self-presentation), is incorporated, human dress is a skin that becomes a skill.

What does it mean to live as image? What does it mean to be transformed suddenly into *fanera*? Moreover, what does it mean that in dress our image becomes something that is incorporated but also constantly alienated? We have claimed that image is not so much a thing as it is the form's mode of existence. Clothing transforms us into image: It transforms our own form into something that is infinitely appropriable and alienable. An article of clothing makes our identity, our nature, into a species, image, something that belongs to us just as much as it could belong to anyone else.

In terms entirely more obvious and technical, one could say that dress is exactly what transforms our whole life into costume, into something that defines us without actually belonging to our Being. In other words, dress (and therefore image) is the place of a perfect coincidence between *bios* and *ethos*, between life and costume, nature and habit. If fashion, therefore, is a faculty of appearance, then it is in the form of our appearance that the definition of our nature is at stake. No living being, no animal that partakes in the sensible life has a *form* of life, because the sensible life is completely defined by fashion.

Life gives itself always and only as costume, dress, habit: This is the most profound truth of the doctrine of evolution. With a brilliant intuition whose metaphysical reach is yet to be truly explored, Lamarck noted that "it is not the organs, that is, the nature and the form of the animal's body parts, which have given rise to its habits and special faculties, but, by contrast, its habits, manner of life, and circumstances of the individuals from which the animal comes to possess, over time, the form of its body, the number and condition of its organs, and finally the faculties which it enjoys."[1] Contemporary philosophy should take up a Lamarckian accent. It is not the nature of a living being that defines its appearance: It is its species, its dress, the way in which it sensibly exists, that decide its nature. "The following maxim has passed into a proverb and is known by all: Habits form a second nature," wrote Lamarck.[2] Let us also recall the ancient adage stating that "clothing makes the man." And if biology long ago discovered that "the environment in which animals habitually live, their special habitats, the habits which circumstances have forced upon them, their manner of life, etc., have a great power to modify organs," philosophy must finally understand

that costumes shape essences, and stop holding that essences express themselves in costumes.[3] We possess our species as a costume, not as an essence; our form is foremost a species, appearance, costume. Fashion is not an accessory, not a luxury, but the most profound and intense nature of everything that participates in the sensible. "The French have taken the word 'fashion' from the Latin, although they have changed its gender," a student of Montaigne once wrote: "In fact just as manners are attached to the things that modify, so to do fashions seem to incorporate the people that love them."[4] The sensible opens life to fashion.

It is only thanks to the sensible that *bios* and *ethos*, life and costume, entirely coincide. Being able to dress and having clothing means, in fact, to have a body that needs other bodies in order to appear, a body that appears in its most true and authentic fashion when it becomes what it is not. And a life that can only be itself through what it is not and through other bodies is a life that is definable only in modal and nonsubstantial, ethical and nonontological terms.

Dress is literally the impossibility for a *bios* to exist without *customs* [*costumi*].[5] Fashion is the impossibility to live without habits [*scostumatamente*] because in reality, all habits are animated clothes (*ethos empsychos*). They are the place where life takes on form and where the forms of the world take on life. In the supernumerary body of dress, our *bios* makes itself habit, and our *ethos* becomes a form of our life, its species.

31

ETHOS

Fashion really ought to be interpreted as a transcendental faculty of the individual: as the power of a body, to have clothes, to transform what is a foreign portion of the world into the place of one's own appearance and truth. A body has fashion when its truth resides in another body. In this sensible appropriation of the foreign (which is always, as we have seen, an alienation of one's own intimacy), what is at stake is one's own aspect, species, and nature.

Understood this way, fashion is the place in which nature must make itself into image and the individual image is immediately demiurgic of one's own nature. It is for this reason that, in fashion, the sensible life absorbs every possible moral. In it one sees how the *ethos* is capable of sensibly designing all features of our *bios*. Fashion is, therefore, the *moral* faculty par excellence. We are moral beings only because we are capable of fashion and

The bird, which is drawn to the water by its need of finding there the prey on which it lives, separates the digits of its feet in trying to strike the water and move about on the surface. The skin that unites these digits at their base acquires the habit of being stretched by these continually repeated separations of the digits; thus, in course of time, there are formed large webs that unite the digits of ducks, geese, and so on, as we actually find them. In the same way, efforts to swim, that is, to push against the water so as to move about in it, have stretched the membranes between the digits of frogs, sea tortoises, the otter, beaver, and so forth.

only because we can have clothes. This is not a question of metaphor. We need other bodies—their colors, their materials, their lines—to make our features appear. The individual *ethos* is the formula of bodies, colors, and appearances that one needs in order to make one's own face appear. Every custom in a moral sense is an *animated dress*, and the dress is a habit reduced to body, which is materially transferable and appropriable by whomever without instruction. By contrast, the transmission of costumes is possible because their nature is fashion and not substance.

Furthermore, it is thanks to fashion that our lives have historical nature. "There is nothing in that which one can call modernity that cannot in some way be considered a custom, and that, thanks to the capriciousness or invention of someone, doesn't later become everyone's experience," Grenaille once wrote.[1] Before propagating ourselves in generations, that is, before becoming heritage, every nature, every species, must exist as a habit, as fashion, as Lamarck taught us.

Nature *lives* first and foremost as *dress* [*veste*]. Or better, it is foremost in dress, in our becoming image, that we first discover the possibility of existing outside and beyond ourselves. The sensible life is exactly this impersonal and diffused eternity, which is indifferent to death as it is to birth: In the sensible life, we can be born and rise again continuously, without ever presupposing a past or a history, and without needing to transform ourselves. We are eternal thanks *only* to fashion, only to the degree in which we are able to transform our most profound nature into dress (acquirable by all) and, vice versa, transform the fashion from which we live into our *nature*. True eternity is not immortality; it is not what awaits us after death. Nor is it what resists our destruction. Rather, it is what is transferable and appropriable by all. Only the sensible is truly eternal; only the image is truly eternal. Fashion is the *organ* of this eternity.

32

LIVING IN IMAGES

Dream, skin, fashion and design, tattoos, experience, language, or biological reproduction: There is a bond between life and images that goes beyond the fact of knowledge and is not reducible to the articulation of substance and accidents, or to nature and operation. The image captures the real (whether this be psychic or object), and transforms it into something that is able to exist beyond itself, on beyond its nature and individuality; the image multiplies the real and renders it infinitely appropriable.

It is in this very meaning that the sensible gives life to what is not alive and gives body to what is living. In fact, every living being can be defined as that which has an essential relationship with an image, as something that holds infinite images within itself—in the form of a consciousness, in the form of the species and of its own appearance and identity. The existence of images is not only a condition of possibility for the existence of life. Above all, it is also the medium, the first world, the first dress of every living being (and together, its specific nudity). Life seems to be a quality of images. Or if this is not the case, it is *only* through images that it can transmit itself, passing from things to subjects, and from these come back to other subjects and to the world. Even if the image is only a state (and not a substance) of what is alive, this state seems to represent its condition, or better, its most obvious consistency. The sensible life makes it so that nothing is reducible to itself; that everything can multiply, exist beyond its substrate, become infinitely appropriable and produce effects (lead to imitation).

The living has a privileged relationship with images, and life exists first and foremost in the state of image, because its most typical movement, its most specific operation consists in transmitting. Biologically, every living

being is what it *inherits*, and it must inherit its own identity. Above all, life is what can be transmitted; life is the very being of tradition. This is why, in the somewhat approximate language of contemporary science, life is defined mainly through reproduction. Reproduction is the highest movement of transmission, where to be conveyed is not only a specific identity but also the very possibility of being. In this perspective, the scientific definition of life is exact, but it should be taken to its most extreme limits. Reproduction is everywhere, in every gesture, material or spiritual: Life never stops producing images of itself and emitting images. And in every image the living multiplies itself.

Reproduction is one of these movements of sensification, perhaps the most radical of them. Our body is already a medium unto itself and for this reason is always divided into clothes and nude, intrabody and anatomical body, dream and wakefulness. Only for this reason is every action of our body always a multiplication and reproduction of itself. The living does nothing but *reproduce* itself in a thousand forms and modes. The sensible, the image, is the actualized being of this infinite reproduction. And every animal is more capable of reproducing itself the more it is touched by the sensible. We shall call life, then, the capacity to hold images and make them emanate.

SOURCES

The quoted passages that appear in boxes are drawn from the following texts: Averroes, *Commentarium magnum in Aristotelis De anima libros*, 1. II, t.c. 74, p. 242 (cap. 5); Aristotle, *De anima*, 419a 15 sqq (cap. 5); J. Peckham, *Perspectiva communis*, 1. II, 19, p. 170 (cap. 7); H. Anzulewicz, *De forma resultante in speculo*, Part I, pp. 285–289 (cap. 7); Egidio Romano, *Quodlibet* (Louvain: Hieronymi Nempaei, 1646), q. V, m. III, d. I, q. 2 (XI), pp. 299–300 (cap. 7); Durandi a S. Portiano, *In Sententias teologicas P Lombardi Commentariorum libri quattuor* (Lyon: Apud Gulielmum Rovillium, Sub scuto veneto, 1563, 1. II, d. XIII, q. I, f. 133 (cap. 9); Averroes, *De sensu et sensato*, p. 31 (cap. 9); Averroes, *Commentarium magnum in Aristotle De anima libros*, 1. II, t.c. 68, p. 235 (cap. 10); Averroes, *De sensu et sensato*, p. 29 (cap. 12); Johannes Marcus Marci de Cronland (Jan Marek Marci), *Philosophia vetus restituta partibus V comprehensa* (Frankfurt-Leipzig, 1676), p. 271 (cap. 14); Helmuth Plessner, *Antropologia dei sensi*, trans. M. Russo (Milan: Cortina, 2008), pp. 88 and 85 (chap. 15); G. Flaubert, *Correspondance, Juillet 1851–Décembre 1858* (Paris: Gallimard, 1980), to Louise Colet, 23 December 1853, pp. 483–484 (chap. 20); Petrus Severinus (Peder Sørensen), *Ideae medicinae philosophiacae continens totius doctirnae paracelsianae Hippocraticae et galienicae* (Basil: Ex officinal sixti Henricpetri, 1571), pp. 58–59 (cap. 24); Albertus Magnus, *De causis et processu universitatis a prima causa*, ed. W. Fauser (Münster: Aschendorff, 1993) (*Alberti Magni Opera Omnia XVII, 2*), p. 42 (cap. 25); G. Van der Leeuw, *Phänomenologie der Religion* (Tübingen: J.C.B. Mohr, 1977) (chap. 27); Heinrich Klemm, *Versuch einer Urgeschichte des Kostüms mit Beziehung auf das allgemeine*

Culturleben der ältesten Völker der Erde (Dresden: H. Klemm, 1860), pp. 1 and 10 (chap. 27); J.-B.P.A. de Lamarck, *Philosophie zoologique* (Paris: Flammarion, 1994), pp. 225–226 (chap. 31).

NOTES

INTRODUCTION

1. This is not to say that the term "sensible," like all philosophical terms, cannot be opened up etymologically and historically to reveal a panoramic (or abyssal) vista of thought. See, for example, the discussion of "Sense/Meaning" in *Dictionary of Untranslatables*, ed. Barbara Cassin et al. (Princeton: Princeton University Press, 2014), 949–967.

2. For a comprehensive account on which this brief sketch draws, see Leen Spruit, *Species Intelligibilis: From Perception to Knowledge*, 2 vols. (Leiden: Brill, 1994–95).

3. Aristotle, *On the Soul. Parva Naturalia. On Breath*, trans. W. S. Hett (Cambridge, Mass.: Harvard University Press, 1936), 137.

4. Augustine, *On the Trinity, Books 8–15*, ed. Gareth B. Matthews, trans. Stephen McKenna (Cambridge: Cambridge University Press, 2002), 64.

5. Aquinas, *Summa theologiae, v. 4*, trans. Thomas Gornall, S.J. (New York: McGraw-Hill, 1964), 7.

6. Spruit, *Species Intelligibilis*, 1:80; my italics.

7. Emanuele Coccia, *La trasparenza delle immagini: Averroè e l'averroismo* (Milan: Bruno Mondadori, 2005), 120.

8. Ibid.

9. René Descartes, *Discourse on Method, Optics, Geometry, and Meteorology*, trans. Paul J. Olscamp (Indianapolis: Hackett, 2001), 68. The *Optics* was published with the *Discourse on Method* in 1637 but written several years before.

10. Ibid., 65.

11. Ibid., 87.

12. Ibid., 67.

13. Ibid., 90.

14. Ibid., 89.

15. Ibid., 133.

16. Jorge Luis Borges, "Averroës' Search," *Collected Fictions*, trans. Andrew Hurley (New York: Viking 1998), 238–239.

1. SENSIBLE LIFE

1. [The Italian *sensibile* has been rendered throughout chiefly with the English "sensible" to mean "perceptible by the senses." For the Italian *sensibilità*, "sensation" is often used, though one ought to hear as well "awareness."—Trans.]

2. MAN AND ANIMAL

1. *The De anima of Alexander of Aphrodisias: A Translation and Commentary*, ed. Athanasios P. Fotinis (Washington, D.C.: University Press of America, 1979), 38, 18–19. Translation slightly modified.

2. Ibid.

3. Ibid., 417 b 25–26.

4. Helmuth Plessner, *Anthropologie der Sinne* (Frankfurt: Suhrkamp, 1980).

3. INTENTIONAL SPECIES

1. René Descartes, *Discourse on Method, Optics, Geometry, and Meteorology*, trans. Paul J. Olscamp (Indianapolis: Hackett, 2001), 68.

2. Thomas Hobbes, *Elements of Law, Natural and Politic* (New York: Routledge, 2013), 4.

3. Nicolas Malebranche, *The Search After Truth* (New York: Cambridge University Press, 1997), 225.

4. Descartes, *Discourse on Method*, 68.

5. Ibid.

4. THE WORLD OF THE SENSIBLE

1. Aristotle, *On the Soul*, in *The Complete Works of Aristotle: Revised Oxford Translation*, ed. Jonathan Barnes (Princeton: Princeton University Press, 1984), 33, translation slightly modified.

2. Ibid., 34, translation slightly modified.

3. Ibid., 51.

4. Giambattista Vico, *The First New Science*, ed. Leon Pompa (Cambridge: Cambridge University Press, 2002), 227.

5. INTERMEDIARIES

1. Aristotle, *On the Soul*, in *The Complete Works of Aristotle: Revised Oxford Translation*, ed. Jonathan Barnes (Princeton: Princeton University Press, 1984), 33.

7. THE PLACE OF THE IMAGES

1. Johannes Peckham, *Perspectiva communis* (1504), 13.

2. Aristotle, *On the Soul*, in *The Complete Works of Aristotle: Revised Oxford Translation*, ed. Jonathan Barnes (Princeton: Princeton University Press, 1984), 31. The full passage reads: "What actual sensation apprehends is individuals, while what knowledge apprehends is universals, and these are in a sense within the soul it-self. That is why a man can think when he wants to but his sensation does not depend upon himself—a sensible object must be there. A similar statement must be made about our knowledge of what is sensible—on the same ground, viz. that the sensible objects are individual and external."

3. Deleuze, Deleuze/Leibniz, Course at Vincennes, May 5, 1980, available at http://www.webdeleuze.com/php/texte.php?cle=130&groupe=Leibniz&langue=2.

8. THE IMAGE IN THE MIRROR

1. H. Anzulewicz, *De forma resultante in speculo*, I:285–289.

9. MICRO-ONTOLOGY

1. Roger Bacon, *Philosophy of Nature: A Critical Edition, with English Translation, Introduction, and Notes, of De multiplicatione specierum and De speculis comburentibus* (South Bend, Ind.: St. Augustine's Press, 1988), 5.

2. Avicenna, *Liber de philosophia prima sive scientia divina*. IX, III, in *Avicenna Latinus, Liber de philosophia prima sive scientia divina V-X*, ed. S. van Riet (Louvain: E. Peeters, 1980), 466, ll. 31–32.

3. Averroes, *Long Commentary on the De Anima of Aristotle*, l. II, t.c. 74, 242.

12. THE PRIMACY OF THE SENSIBLE

1. Maurice Merleau-Ponty, "Eye and Mind," in *The Merleau-Ponty Reader* (Evanston, Ill.: Northwestern University Press, 2007), 352.

2. Ibid.

3. Maurice Merleau-Ponty, *Phenomenology of Perception*, trans. Donald A. Landes (New York: Routledge, 2012).

19. BECOMING WHAT ONE SEES

1. Jacques Lacan, *Écrits*, trans. Bruce Fink (New York: Norton, 1996), 75–76.
2. Ibid., 78.
3. Ibid., 77.
4. Ibid.
5. Ibid., 75.
6. Ibid., 76.
7. Ibid., 78.
8. Ibid.
9. Ibid., 76.
10. Ibid.
11. Ibid.
12. Jacques Lacan, "The Nucleus of Repression," *The Seminar of Jacques Lacan, Book 1: Freud's Papers on Technique 1953–1954*, trans. John Forrester (New York: CUP Archive, 1988), 193.
13. Jacques Lacan, *The Seminar of Jacques Lacan, Book II: The Ego in Freud's Theory and in the Technique of Psychoanalysis 1954–1955*, trans. John Forrester (New York: CUP Archive, 1988), 54.
14. Lacan, *Écrits*, 76.

20. LOSING ONESELF IN IMAGES

1. Jacques Lacan, *Écrits*, trans. Bruce Fink (New York: Norton, 2006), 93.

21. DREAM

1. Saint Synesius, *On Dreams*, trans. Isaac Myer (Philadelphia, 1888), 7.
2. Ibid., 27.
3. Ibid., 16.

22. THE INTRABODY

1. José Ortega y Gasset, "Vitalidad alma, espíritu," in *El Espectador* (Madrid: Espasa Calpe, 1966).
2. Ibid.
3. William James, *Psychology: The Briefer Course* (Toronto: General Publishing, 2001), 19.

23. BEING CONSTANTLY ELSEWHERE

1. Theophrast von Hohenheim (Paracelsus), *De virtute imaginativa fragmentum*, in Paracelsus, *Sämtliche Werke 1, 14, Das Volumen primum der Philosophia magna. Spuria: Unechte, von Johannes Huser größtenteils für echt gehaltene Schriften unter Hohenheims Namen* (Munich: Barth, 1933), 309–319, at 309.

2. Ibid.

26. ON THE SURFACE OF THE SKIN

1. All quotations are from A. Portmann, *Le forme viventi. Nuove prospettive della biologia*, trans. B. Porena (Milan: Adelphi, 1989).

27. METAPHYSICS OF CLOTHING

1. Georg Simmel, *Simmel on Culture: Selected Writings*, ed. David Frisbee and Mike Weatherstone (London: Sage, 2000), 207.

2. Ibid. (emphasis in original).

3. Georg Simmel, *The Sociology of Georg Simmel*, trans. Kurt H. Wolf (New York: Free Press, 1950), 340.

4. Ibid., 339.

30. THE BODY OF CLOTHING

1. Jean-Baptiste Lamarck, *Zoological Philosophy: An Exposition with Regard to the Natural History of Animals* (Cambridge: Cambridge University Press, 2011), 114.

2. Ibid.

3. Ibid., 74.

4. François de Grenaille, *La Mode, ou Charactère de la religion, de la vie, de la conversation, de la solitude, des compliments, des habits et du style du temps* (Paris: N. Gassé, 1642).

5. [The author is punning here between "customs" and "costumes" and their shared etymology in the Italian *costume*, meaning "custom, use, wont, fashion, guise, habit, manner."—Trans.]

31. ETHOS

1. François de Grenaille, *La mode, ou charactère de la religion, de la vie, de la conversation, de la solitude, des compliments, des habits et du style du temps* (Paris: N. Gassé, 1642).

COMMONALITIES

Timothy C. Campbell, series editor

Roberto Esposito, *Terms of the Political: Community, Immunity, Biopolitics.* Translated by Rhiannon Noel Welch. Introduction by Vanessa Lemm.

Maurizio Ferraris, *Documentality: Why It Is Necessary to Leave Traces.* Translated by Richard Davies.

Dimitris Vardoulakis, *Sovereignty and Its Other: Toward the Dejustification of Violence.*

Anne Emmanuelle Berger, *The Queer Turn in Feminism: Identities, Sexualities, and the Theater of Gender.* Translated by Catherine Porter.

James D. Lilley, *Common Things: Romance and the Aesthetics of Belonging in Atlantic Modernity.*

Jean-Luc Nancy, *Identity: Fragments, Frankness.* Translated by François Raffoul.

Miguel Vatter, *Between Form and Event: Machiavelli's Theory of Political Freedom.*

Miguel Vatter, *The Republic of the Living: Biopolitics and the Critique of Civil Society.*

Maurizio Ferraris, *Where Are You? An Ontology of the Cell Phone.* Translated by Sarah De Sanctis.

Irving Goh, *The Reject: Community, Politics, and Religion after the Subject.*

Kevin Attell, *Giorgio Agamben: Beyond the Threshold of Deconstruction.*

J. Hillis Miller, *Communities in Fiction*.

Remo Bodei, *The Life of Things, the Love of Things*. Translated by Murtha Baca.

Gabriela Basterra, *The Subject of Freedom: Kant, Levinas*.

Roberto Esposito, *Categories of the Impolitical*. Translated by Connal Parsley.

Roberto Esposito, *Two: The Machine of Political Theology and the Place of Thought*. Translated by Zakiya Hanafi.

Akiba Lerner, *Redemptive Hope: From the Age of Enlightenment to the Age of Obama*.

Adriana Cavarero and Angelo Scola, *Thou Shalt Not Kill: A Political and Theological Dialogue*. Translated by Margaret Adams Groesbeck and Adam Sitze.

Massimo Cacciari, *Europe and Empire: On the Political Forms of Globalization*. Edited by Alessandro Carrera, Translated by Massimo Verdicchio.

Emanuele Coccia, *Sensible Life: A Micro-ontology of the Image*. Translated by Scott Alan Stuart, Introduction by Kevin Attell.

www.ingramcontent.com/pod-product-compliance
Lightning Source LLC
Chambersburg PA
CBHW032150020426
42334CB00016B/1254